STANDARD BOOK OF

BALENCIAGA

1919

Chloé Kamali-Worth

STANDARD BOOK OF

BALENCIAGA

1919

CHLOE KAMALI-WORTH

Copyright © 2024 All rights reserved. No part of this publication may be reproduced, distributed or transmitted in any form or by any means, including photocopying, recording, or other electronic or mechanical methods, without the prior written permission of the publisher, except in the case of brief quotations embodied in reviews and certain other non-commercial uses permitted by copyright law.
Any references to historical events, real people or real places may be real or used fictitiously to respect anonymity. Names, characters and places may be the product of the author's imagination.

Balenciaga is a luxury haute couture house founded in 1919 by Spanish designer Cristóbal Balenciaga in San Sebastián, Spain. Today, its headquarters is in Paris, France. Balenciaga is known for its innovative and often avant-garde designs, influencing many other fashion designers and trends over the years.

Balenciaga has a rich history of revolutionary designs. Cristóbal Balenciaga himself was renowned for his exceptional craftsmanship and innovative silhouettes. He was called "the master" of haute couture by his contemporaries and had a significant influence on the fashion industry with his techniques and unique vision.

The codes of luxury
BALENCIAGA

Innovation and Avant-garde: Balenciaga is renowned for its innovative and avant-garde approach to fashion. The house is often at the forefront of trends, using unconventional materials and creating unique silhouettes that challenge traditional fashion norms.

Exceptional Craftsmanship: The quality of the tailoring is at the heart of Balenciaga's creations. Attention to detail, precision sewing and the use of high quality materials are essential. This meticulous craftsmanship is reflected in the longevity and superior quality of their products.

Exclusivity and Elitism: Balenciaga maintains a high level of exclusivity, with prices reflecting the luxury and quality of their products. This exclusivity is reinforced by limited editions and unique collaborations.

Distinctive Aesthetic: Balenciaga has a distinct aesthetic that often mixes the classic with the modern. Their style can be both bold and subtle, with a balance between experimentation and sophistication.

Cultural Influence: The brand is not limited to fashion; it also influences popular culture. Balenciaga often collaborates with artists, musicians and celebrities, integrating fashion into a broader cultural context.

Heritage and History: Balenciaga has a rich historical heritage. The tradition and history of the brand are often highlighted, while being adapted to contemporary tastes and trends.

Marketing and Branding: The way Balenciaga markets itself, including its advertising campaigns, social media presence, and fashion shows, also contributes to its luxury image. Their marketing is often as innovative as their creations.

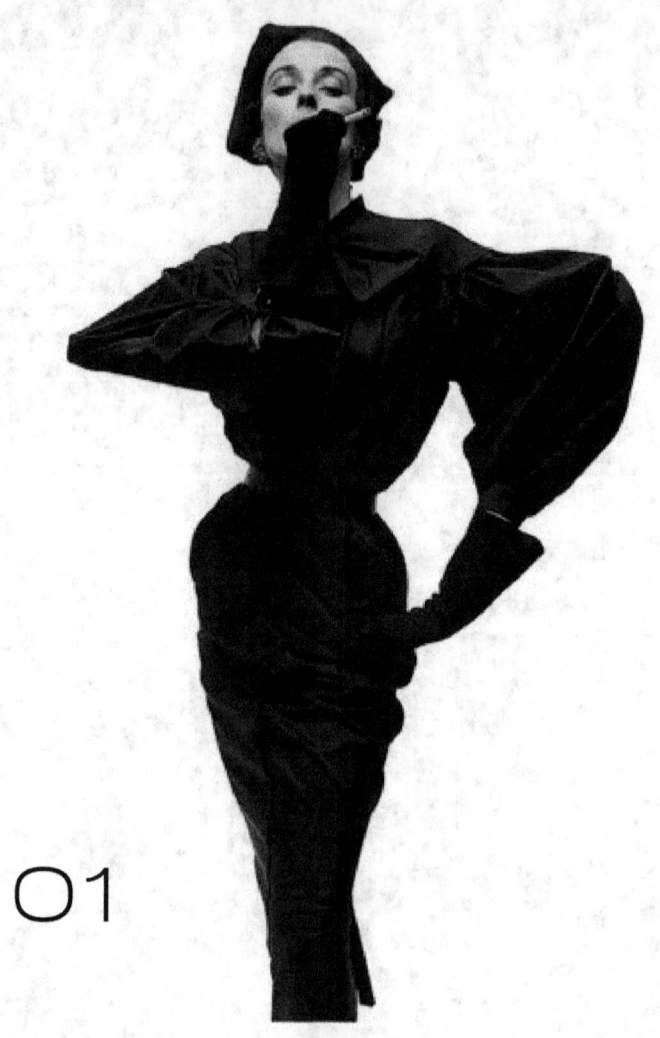

01

Balenciaga is famous for revolutionizing the female silhouette in the 1950s, introducing designs such as the tunic dress, baby doll dress and sack dress.

The beginnings

Balenciaga's beginnings date back to 1919, when Cristóbal Balenciaga opened his first boutique in San Sebastián, Spain. Born in 1895 in a small Basque fishing village, Balenciaga was introduced to sewing at a young age by his mother, who was a seamstress. His exceptional talent and eye for design quickly gained him recognition among the Spanish aristocracy, who appreciated his meticulous attention to detail and his ability to create elegant and sophisticated clothing.

The Spanish Civil War forced Balenciaga to close his boutiques in Spain and move to Paris, where he opened his fashion house in 1937. It was in Paris that Balenciaga really began to make his mark in the world of high fashion. sewing. His first show was critically acclaimed, and he quickly earned a reputation as an innovator, known for his revolutionary silhouettes, such as the "sack" dress, tunic, and "baby doll" blouse. Balenciaga was a perfectionist who controlled every aspect of production, from design to finishing, allowing him to work with new materials and develop innovative sewing techniques.

Balenciaga's approach to fashion was radically different from that of his contemporaries. He favored the structure and shape of the garment, often manipulating the fabric directly on the mannequin to create unique shapes. His mastery of black, considered the most difficult color to work with, revealed his incredible sense of depth and texture.

Despite his influence and success, Balenciaga remained a mysterious and elusive figure, avoiding the spotlight and refusing to conform to commercial fashion trends. He closed his fashion house in 1968, withdrawing from the fashion scene at a time when the industry was beginning to shift toward ready-to-wear. Cristóbal Balenciaga died in 1972, but his legacy lives on, with the Balenciaga brand continuing to be a major force in luxury fashion, renowned for its innovation and avant-garde under the leadership of various artistic directors who followed.

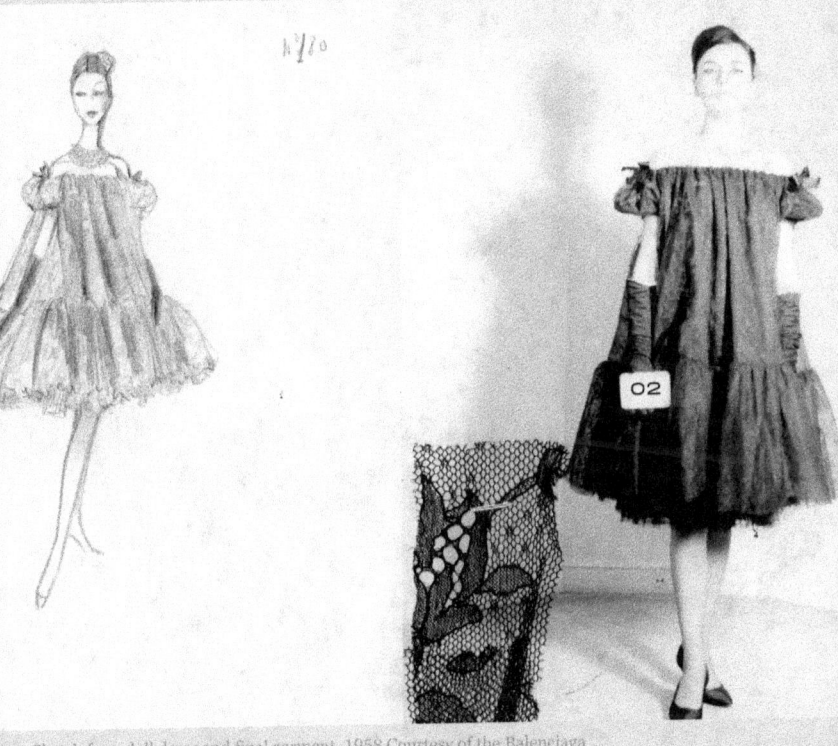

Sketch for a doll dress and final garment, 1958 Courtesy of the Balenciaga Archives, Paris

02

The baby doll dress is one of Cristóbal Balenciaga's most iconic contributions to fashion, illustrating his talent for rethinking the female silhouette in innovative ways. Introduced in the 1950s, this design marked a significant departure from the fitted, cinched shapes that dominated fashion at the time.

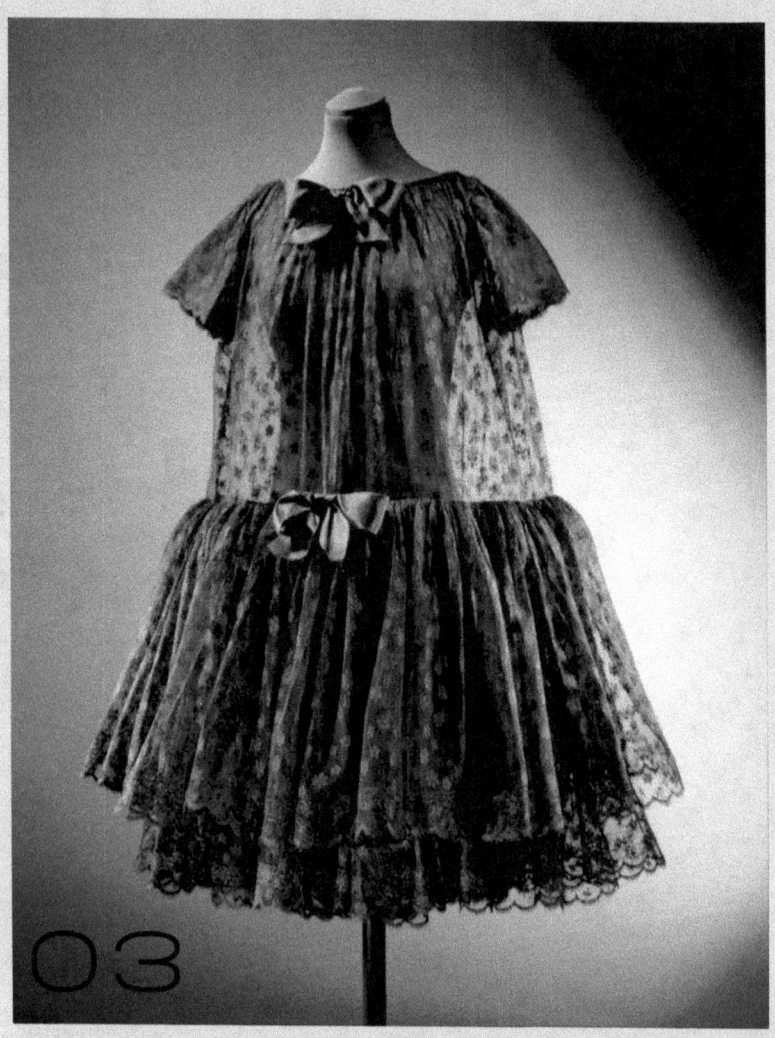

The most fascinating story about the baby doll dress lies in its revolutionary design, which offered unprecedented freedom of movement while maintaining a refined and elegant aesthetic. Balenciaga used advanced sewing techniques to create a dress that appeared to float around the body, unconstrained at the waist or hips, a characteristic that defined most women's outfits of the era.

La robe baby doll

This liberating approach to women's fashion was not just a technical feat; it also reflected a change in the perception of women and their bodies in society.

Balenciaga's baby doll dress was both simple and sophisticated, often made using luxurious, lightweight fabrics that accentuated its volume and flow. This piece has become emblematic of the innovation of Balenciaga, who preferred his clothes to speak for him. His ability to anticipate and influence fashion trends, while remaining true to his unique vision, has solidified his legendary status in the industry.

The introduction of the baby doll dress not only revolutionized women's fashion but also proved that Balenciaga was a master of innovation, capable of reshaping not only fabrics but also the social conventions of his time. Today, the baby doll dress is considered a milestone in fashion history, a testament to Balenciaga's avant-garde spirit and enduring legacy.

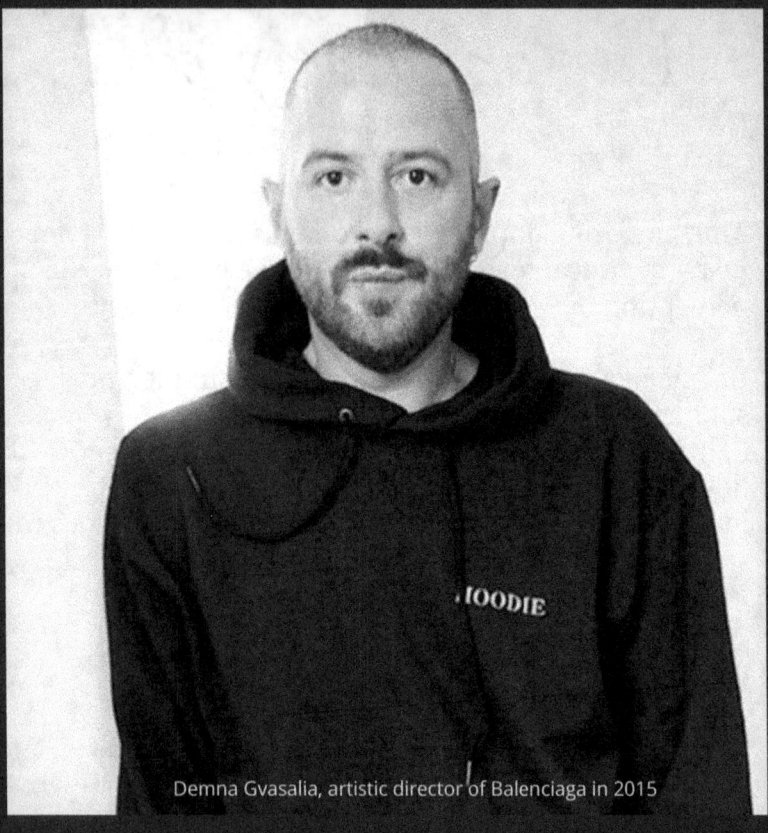

Demna Gvasalia, artistic director of Balenciaga in 2015

04

In recent years, Balenciaga has continued to push boundaries under the leadership of various creative directors.

Demna Gvasalia, who became creative director of Balenciaga in 2015, is widely credited with bringing new energy and an avant-garde perspective to the historic brand.

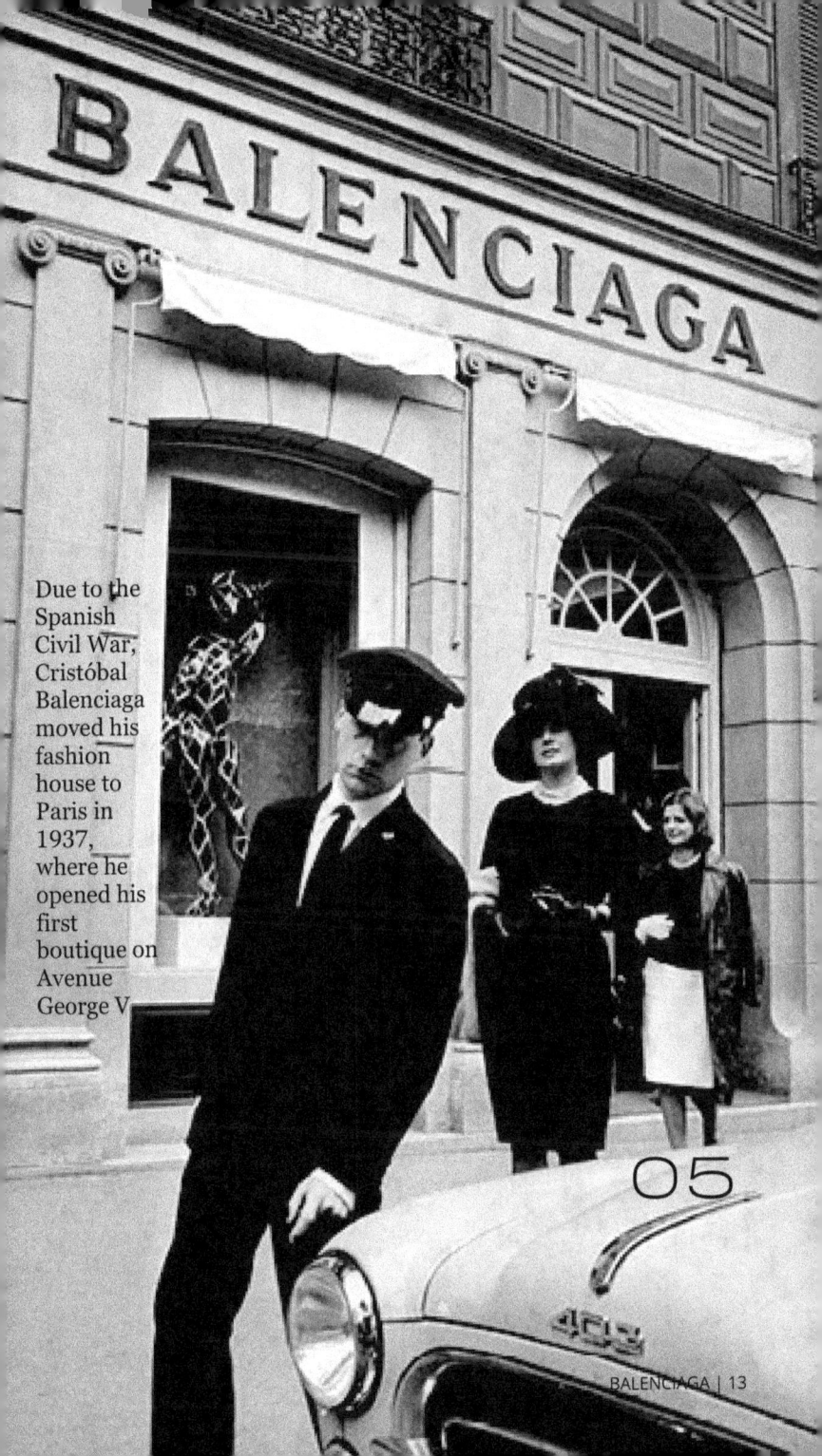

Due to the Spanish Civil War, Cristóbal Balenciaga moved his fashion house to Paris in 1937, where he opened his first boutique on Avenue George V

05

Christian Diòr featured on a CBS celebrity interview program called "Person to Person", November 7, 1955.

06

Cristóbal Balenciaga was so respected in the fashion industry that Christian Dior nicknamed him

❝ *the master of us all* **❞**

Cristóbal Balenciaga's closure of his fashion house in 1968 marked the end of an era in the world of haute couture, reflecting his reservations about the fashion industry's rapid shift toward ready-to-wear, carrying and marketing. After a period of dormancy, the relaunch of Balenciaga in 1986 under the aegis of the Jacques Bogart S.A. group marked the beginning of a new chapter for the brand, seeking to preserve the legacy of its founder while adapting it to the demands of the modern market.

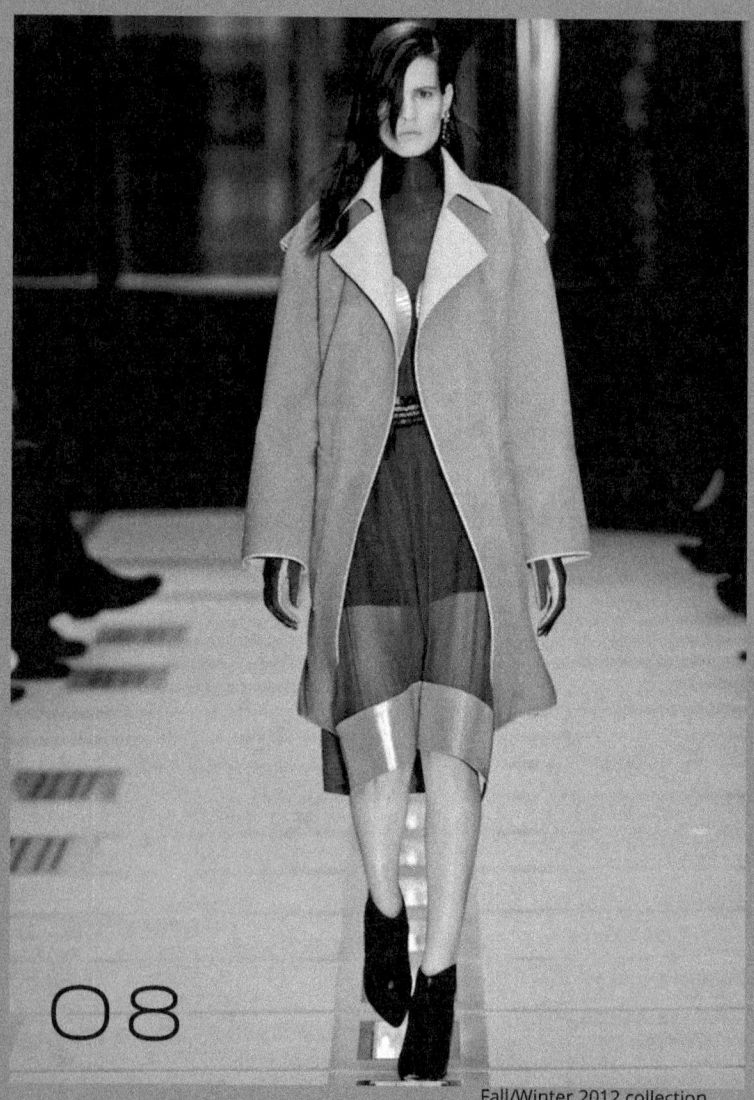

08

Fall/Winter 2012 collection

One of Balenciaga's most iconic garments that uses non-traditional materials is the neoprene jacket from the Fall/Winter 2012 collection.

Neoprene from the Fall/Winter 2012 collection

The use of neoprene by Balenciaga, notably in the jacket of the Fall/Winter 2012 collection, marked a turning point in the perception of materials traditionally used in fashion. Neoprene, with its unique texture and ability to maintain a structured shape, has allowed Balenciaga to explore new silhouettes and push the boundaries of clothing design. The jacket in question illustrated how one material can completely transform the look and feel of a garment, providing both volume and definition without the addition of padding or rigid underwire.

This piece not only highlighted neoprene as a viable and attractive option for high fashion, but also encouraged a broader exploration of the technical and aesthetic properties of unconventional materials in fashion. By choosing neoprene, Balenciaga communicated a vision of fashion where material functionality and innovation are not at odds with luxury and elegance.

Beyond the neoprene jacket, Balenciaga continued to experiment with a range of unusual materials, including latex and various forms of synthetic textiles, each bringing a new dimension to traditional clothing design. This approach has not only strengthened Balenciaga's reputation as a leader in fashion innovation, but also contributed to a broader trend in the industry toward experimentation and adoption of advanced technologies and materials.

Ultimately, Balenciaga's use of neoprene opened the door to endless creative possibilities, demonstrating that the boundaries of fashion are only defined by the imagination of designers. This philosophy continues to inspire current designers at Balenciaga and other fashion houses, continuing the legacy of innovation and reinvention that is at the heart of the brand.

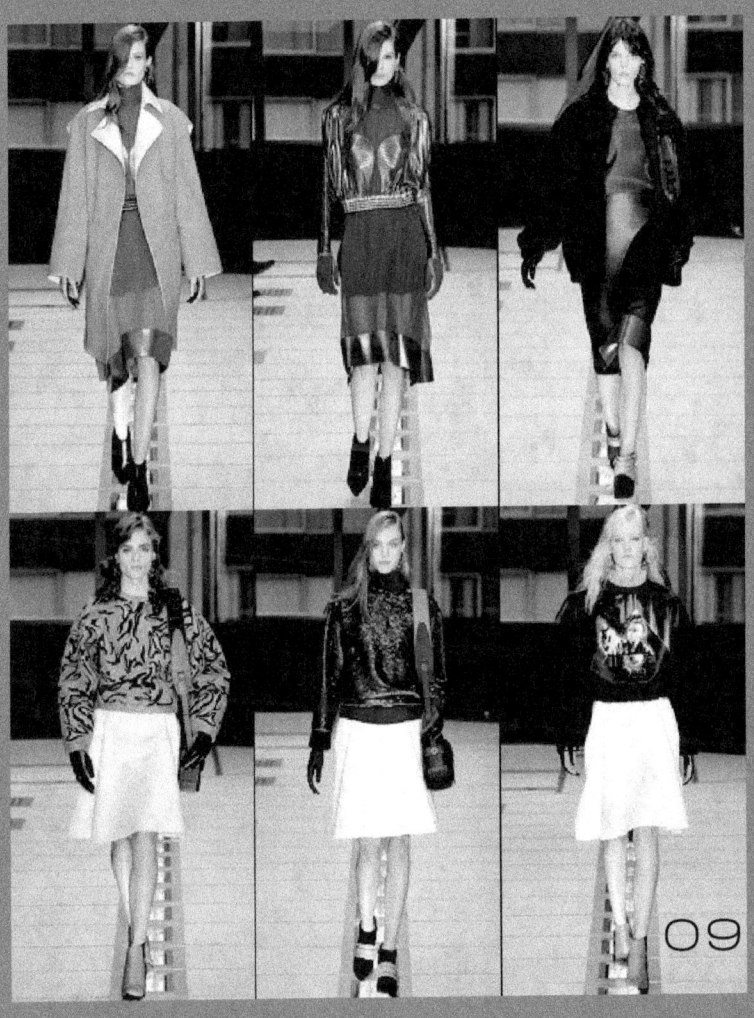

Balenciaga is known for introducing several innovations, including the use of fabrics like latex, neoprene, and other non-traditional materials in its designs.

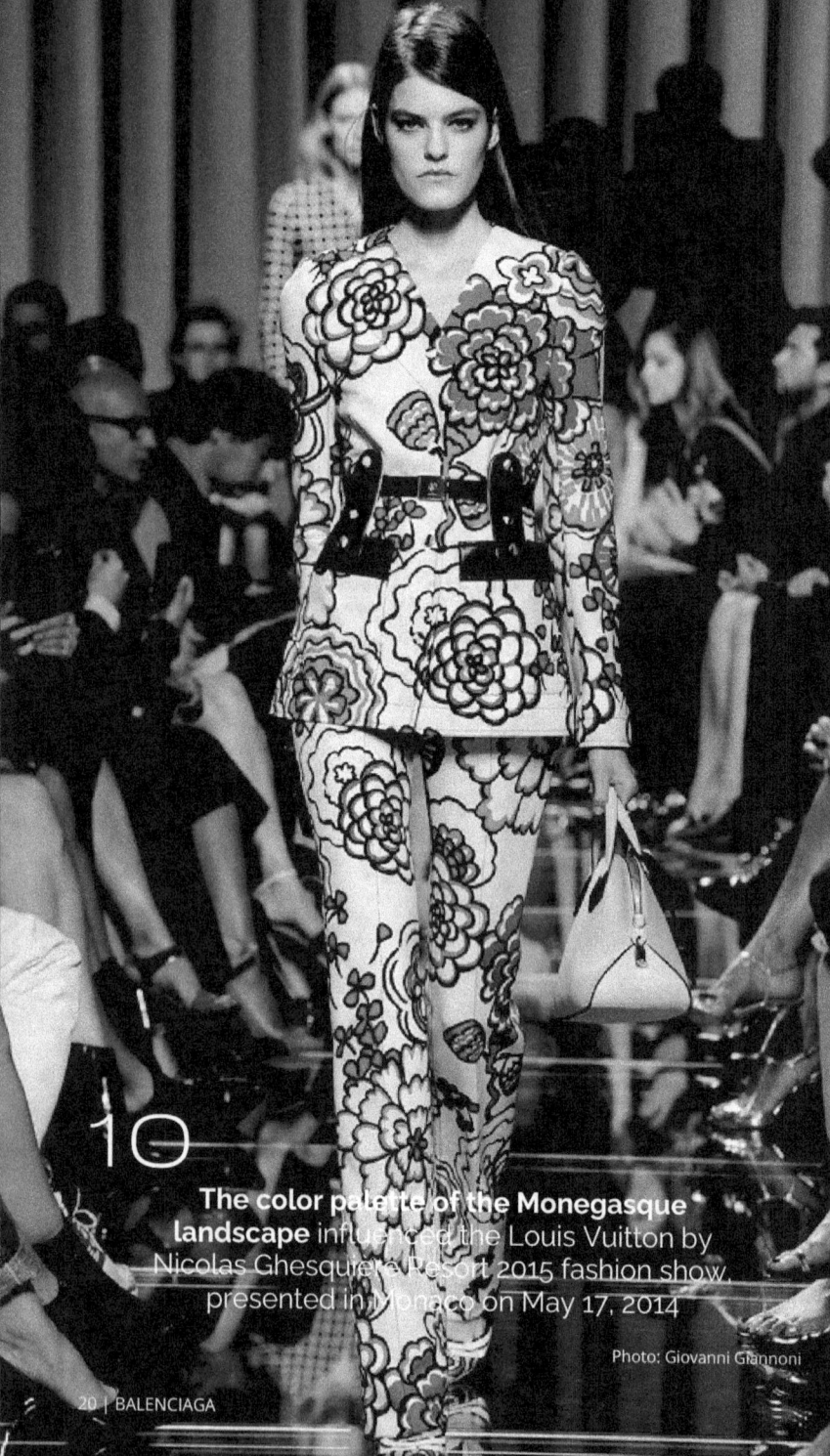

10

The color palette of the Monegasque landscape influenced the Louis Vuitton by Nicolas Ghesquière Resort 2015 fashion show, presented in Monaco on May 17, 2014

Photo: Giovanni Giannoni

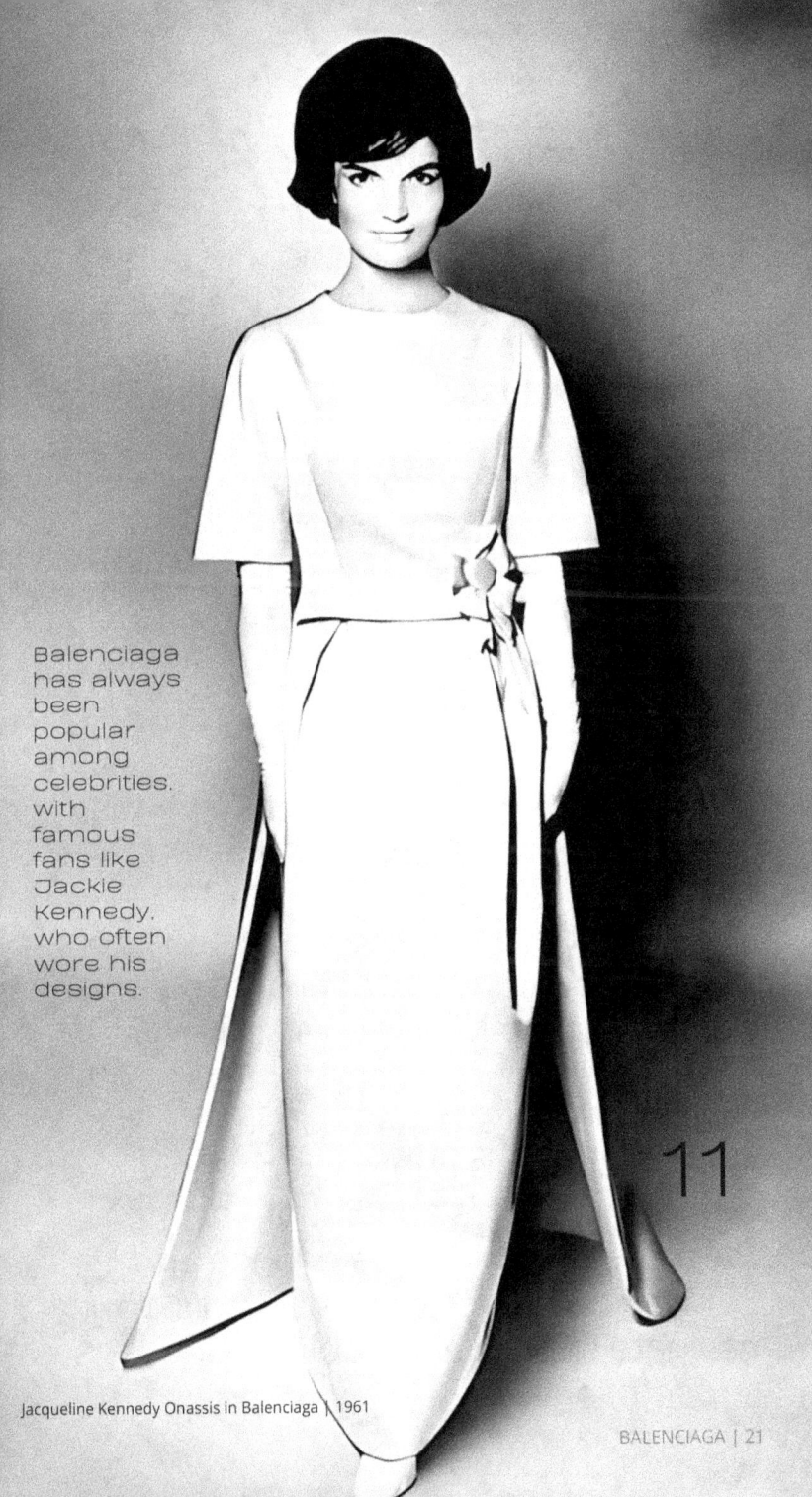

Balenciaga has always been popular among celebrities, with famous fans like Jackie Kennedy, who often wore his designs.

Jacqueline Kennedy Onassis in Balenciaga | 1961

The Secret History of Jackie Kennedy and Balenciaga

Jackie Kennedy, one of the most elegant and influential first ladies of the United States, was a great admirer of Balenciaga's designs.

An interesting fact about their connection is how Jackie incorporated Balenciaga outfits into her wardrobe, despite political and public criticism. At a time when excessive spending on fashion, especially from foreign fashion houses, could be frowned upon by the American public, Jackie Kennedy found a clever solution to continue wearing Balenciaga.

She often called on Oleg Cassini, her personal couturier, to adapt or recreate Balenciaga designs, allowing the first lady to present an image that was both refined and aware of national sensibilities. This approach not only demonstrated his admiration for Balenciaga's timeless elegance and innovation, but also his ability to skillfully navigate fashion and public image expectations.

Balenciaga's influence on Jackie Kennedy's style highlights the brand's international reach and impact on high-profile figures.

Despite the challenges, Jackie managed to wear Balenciaga-inspired designs with a grace and elegance that helped cement her status as a fashion icon. This anecdote illustrates not only the special relationship between Jackie Kennedy and Balenciaga's designs, but also how fashion can transcend cultural and political boundaries, becoming a tool for personal expression and diplomacy.

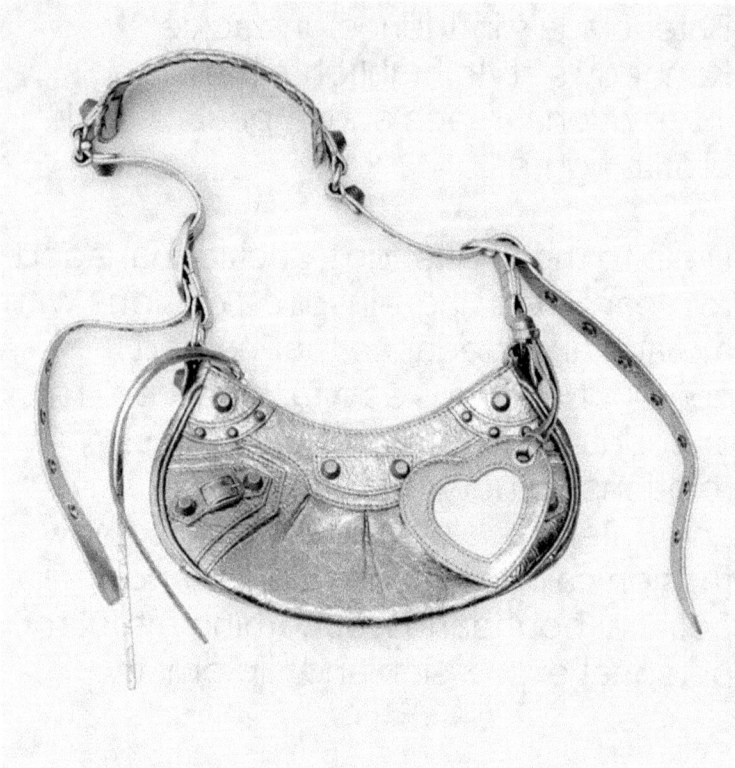

12

In addition to haute couture, Balenciaga produces ready-to-wear lines, shoes, handbags, and other accessories.

ICONIC DESIGN

PREVIEW

[SACS]

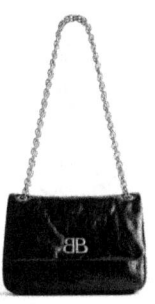 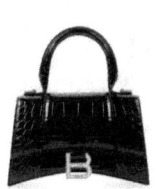 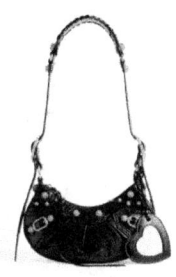

Balenciaga bags are iconic in the world of luxury fashion, combining innovative design with exceptional functionality. Cristóbal Balenciaga himself laid the foundations for an approach that combines high-quality craftsmanship with an avant-garde aesthetic. Bags such as the 'City' and the 'Motorcycle' have gained a cult reputation, known for their supple leather, distinctive metal details and sleek yet practical silhouette.

BALENCIAGA

TRENDS PROJECTS
COLLECTIONS FACES
DESIGNERS AWARDS

NEW-YORK 🌐

BALENCIAGA.COM

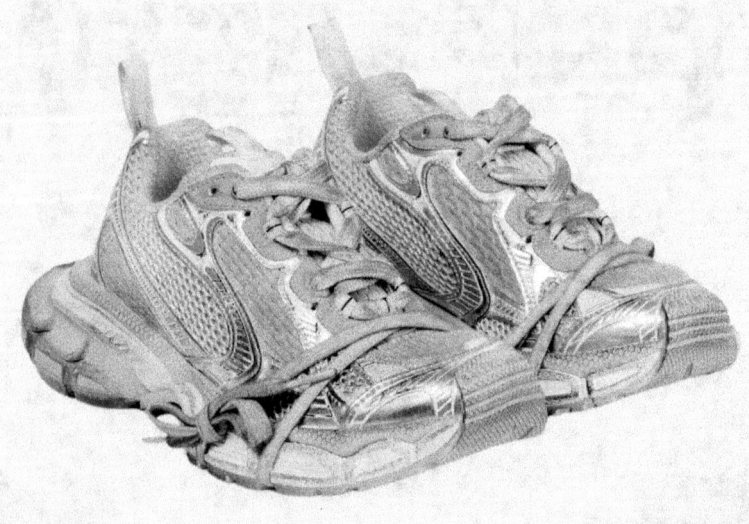

13

Balenciaga fully embraces the outdoors-inspired trend with the **3xl sneakers**. Taking the high-performance know-how used in hiking and running models, this model in shimmering technical mesh reveals a vintage worn effect.

14

Balenciaga's **Triple S** sneakers, with their voluminous, layered design, have become a fashion phenomenon and a symbol of the "ugly sneaker" trend in the fashion industry.

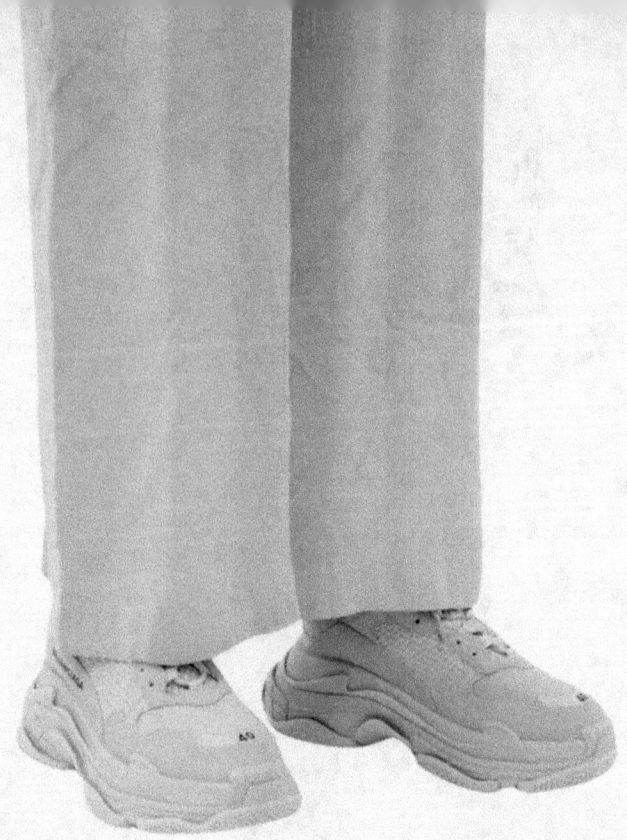

15

The striking chunky sole of Balenciaga's beige **faux-leather Triple S** sneakers is designed in the mold of running, basketball and athletic sneakers.

Shown here with: Balenciaga Logo-jacquard crinkled-silk wide-leg pants

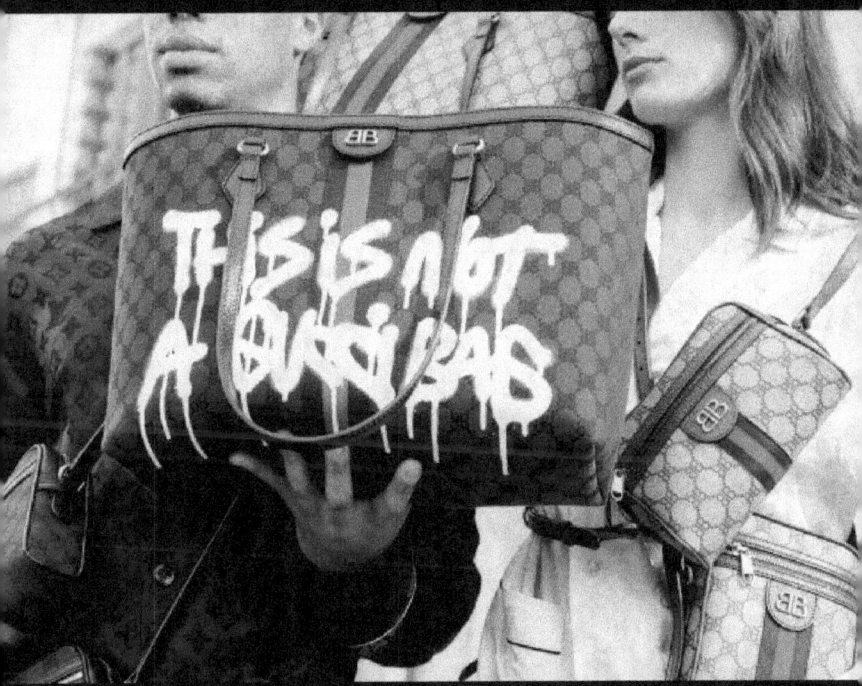

16

Balenciaga has collaborated with many renowned brands and designers, including a high-profile collection with Gucci named **"The Hacker Project."**

Hacking Haute Couture: The Intriguing Collaboration between Balenciaga and Gucci

"**The Hacker Project**" between Balenciaga and Gucci is how this collaboration deliberately blurred the lines between the two luxury houses, challenging traditional notions of branding and authenticity in fashion. Instead of a typical collaboration where the brands combine their aesthetics in a harmonious way, "The Hacker Project" saw Balenciaga "hack" Gucci's iconic designs, and vice versa, creating a series of pieces that fused the visual signatures of each marks in a provocative and unexpected way.

What makes this collaboration particularly **fascinating is the use of the term "hacker"**, often associated with cybercrime and unauthorized intrusion. By claiming this term, the two brands have transformed the act of "hacking" into a positive creative exploration, highlighting a form of mutual admiration and respect between them. This approach not only generated significant buzz around the collection, but also stimulated a broader discussion about copyright, imitation and inspiration in fashion.

One of the most exciting aspects of "The Hacker Project" was how the final products were presented in stores and online. Pieces in the collection bore labels from both brands, blending the iconic logos and motifs of Balenciaga and Gucci in a way that challenged consumer expectations and luxury fashion conventions. This initiative not only demonstrated the ingenuity and forward-thinking spirit of both houses, but also served as a playful commentary on counterfeit culture and the desire for authenticity in the fashion industry.

Gucci's "Hacking" Of Balenciaga Is A Fashion Power Move

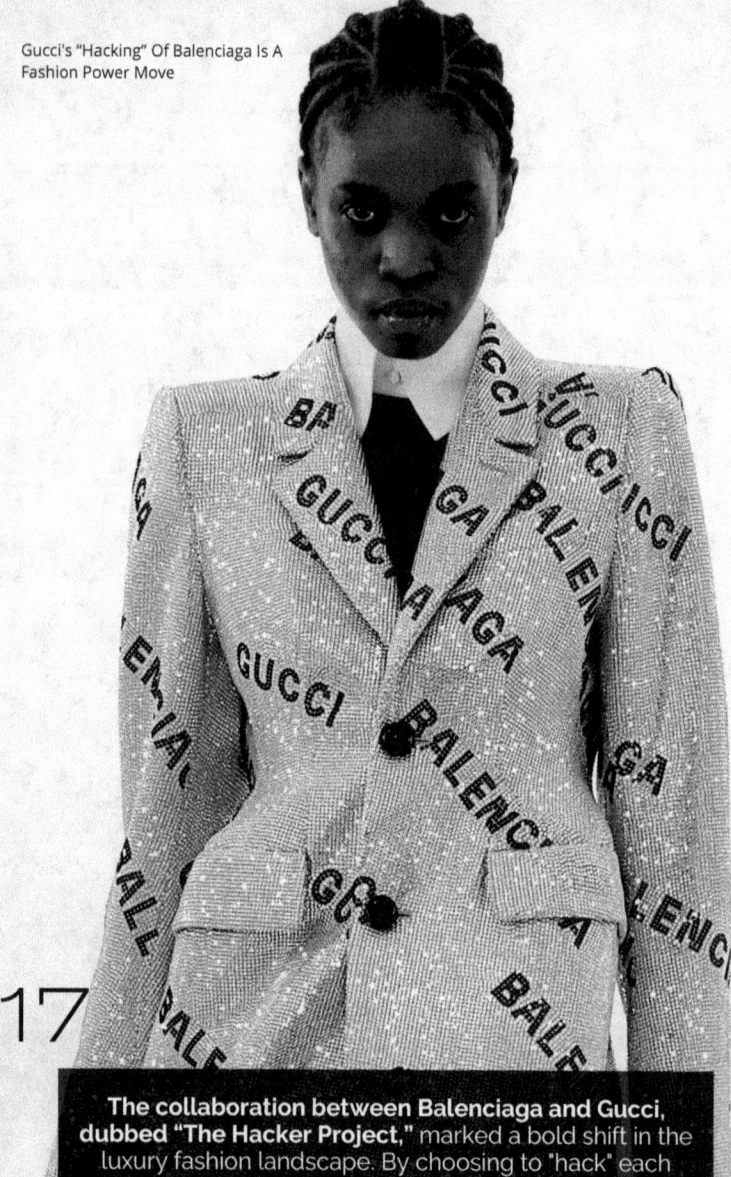

17

The collaboration between Balenciaga and Gucci, dubbed "The Hacker Project," marked a bold shift in the luxury fashion landscape. By choosing to "hack" each other's collections, these two fashion giants not only merged their distinct visual identities but also asked provocative questions about originality, authenticity and imitation in the fashion industry. .

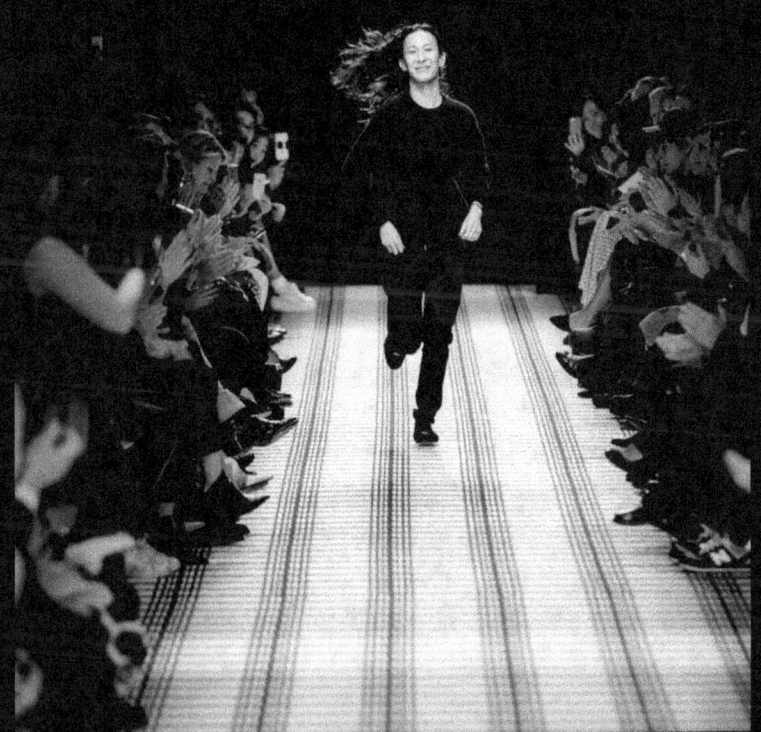

Alexander Wang at the end of the Balenciaga fall-winter 2015 show - © PixelFormula

18

After Nicolas Ghesquière, **Alexander Wang** took over as artistic director from 2012 to 2015. Then, Demna Gvasalia, co-founder of Vetements, took over as artistic director of Balenciaga in 2015, bringing his unique and often provocative approach to the brand.

Alexander Wang chez Balenciaga

Alexander Wang, known for his urban aesthetic and avant-garde approach to fashion, took the reins of Balenciaga as artistic director in 2012, succeeding Nicolas Ghesquière. His appointment marked a new era for the historic fashion house, bringing contemporary energy while paying homage to the legacy of Cristóbal Balenciaga.

During his tenure at Balenciaga, Wang has fused his sense of modern style with the elegance and precision for which Balenciaga is renowned. He skillfully balanced innovation and respect for tradition, emphasizing clean silhouettes, luxurious materials and meticulous attention to detail. Wang introduced a touch of youth and freshness to the brand, while retaining the essence of sophistication and artisanal quality that defines Balenciaga.

One of Alexander Wang's notable contributions to Balenciaga was his ability to interpret tailoring in a modern context. His home collections often reflected a deep understanding of structure and form, key attributes of Balenciaga's aesthetic, while incorporating contemporary design elements that spoke to a new generation of fashion consumers.

Wang has been applauded for his ability to navigate the world of luxury fashion while remaining true to his personal brand identity. He brought a global vision to Balenciaga, drawing inspiration from street culture and merging diverse influences to create pieces that were both innovative and instantly recognizable.

His time at Balenciaga was also marked by collaborations and creative initiatives that strengthened the brand's presence in the digital world and among younger audiences. Wang was able to capture the spirit of the times, aligning Balenciaga with contemporary trends and cultural dialogues.

Although Alexander Wang left Balenciaga in 2015, his influence lives on in the way the brand continues to evolve. His tenure helped redefine Balenciaga for the 21st century, proving that respect for tradition can coexist with a bold exploration of the new and unexpected in luxury fashion.

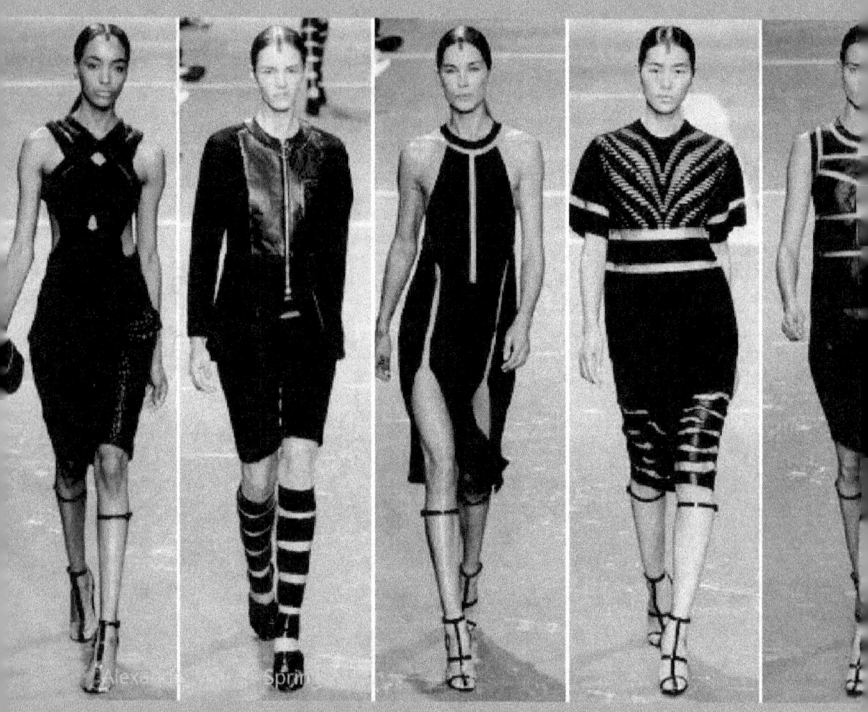

19

The Taiwanese-born prodigy is officially the new creative director at Balenciaga. Nicolas Guesquière leaves his position after 15 years of collaboration.

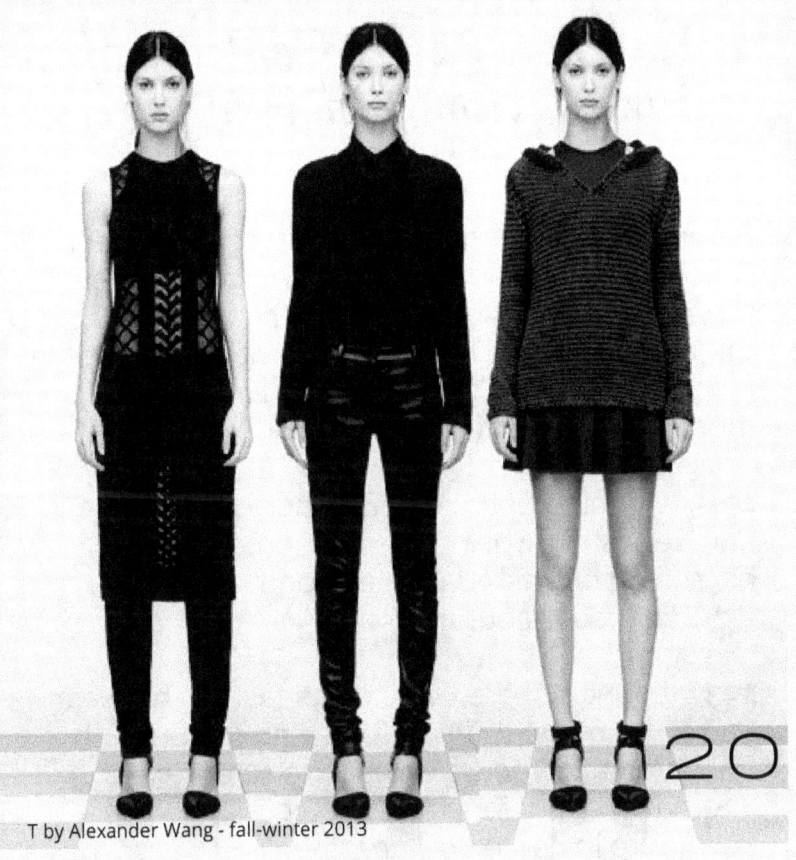

T by Alexander Wang - fall-winter 2013

Graduating from Parsons School of Design in New York in 2005, Alexander Wang, an extremely gifted designer, began his career as an assistant at Teen Vogue. Quickly, in 2007, he unveiled his first ready-to-wear collection, followed, two years later, by the launch of his secondary line, "T by Alexander Wang". That same year, he distinguished himself by winning an award from the Vogue/CFDA Fashion Fund. At just 28 years old, this daring young designer opened his first iconic boutique in Manhattan. Today, he accepts the challenge of leading one of the most prestigious French fashion houses.

Balenciaga: A Century of Innovation and Heritage

Balenciaga, under the leadership of its founder Cristóbal Balenciaga, experienced several key moments that not only defined the trajectory of the brand but also had a significant impact on the fashion industry in general. Here are some of those notable moments:

1919: Opening of the first Balenciaga boutique in San Sebastián, Spain. This event marks the beginning of Cristóbal Balenciaga's rise in the world of haute couture.

1937: Launch of the Balenciaga fashion house in Paris. The move to Paris, following the Spanish Civil War, allowed Balenciaga to reach an international audience and establish itself as a key figure in haute couture.

1950: Revolution of the female silhouette. During this decade, Balenciaga introduced several innovative designs, including the "tunic" dress, the "baby doll" dress and the "bag" silhouette, which redefined women's fashion.

1957: Creation of the "sac" dress. This iconic design eliminated the traditional cinched waist, offering a new form of freedom and comfort in women's clothing.

1968: Closure of the Balenciaga fashion house. Cristóbal Balenciaga decides to close his fashion house in reaction to the industry's shift towards ready-to-wear and in protest against the commercialization of fashion.

1972: Death of Cristóbal Balenciaga. The founder's death marks the end of an era, but his legacy continues to influence fashion. 1986: Relaunch of Balenciaga. After a period of inactivity, the brand was relaunched under the leadership of new designers, marking the start of a new era for Balenciaga.

1997: Nicolas Ghesquière becomes artistic director. Ghesquière introduces a modern and innovative aesthetic that revitalizes the brand and makes it relevant for a new generation.

2015: Demna Gvasalia takes over as artistic director. Under his leadership, Balenciaga is undergoing a radical reinvention, with a fusion of luxury and streetwear that captures the spirit of the 21st century.

Present: Balenciaga continues to be a major force in the fashion industry, known for its avant-garde approach and cultural influence that extends far beyond the boundaries of fashion.

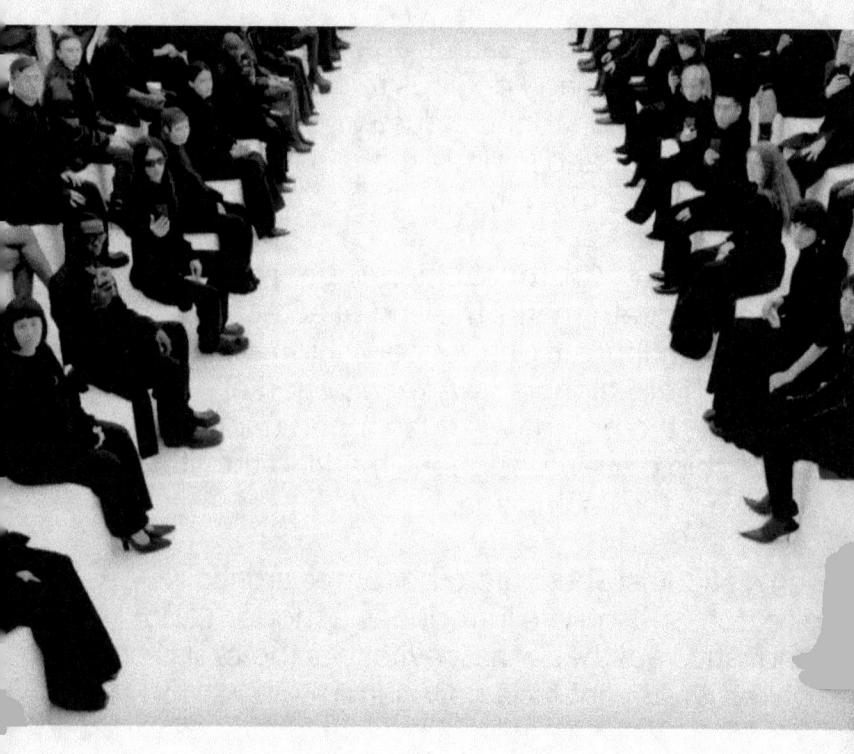

21

The brand has embraced digital, using innovative technologies for its fashion shows and communications, including augmented and virtual reality presentations.

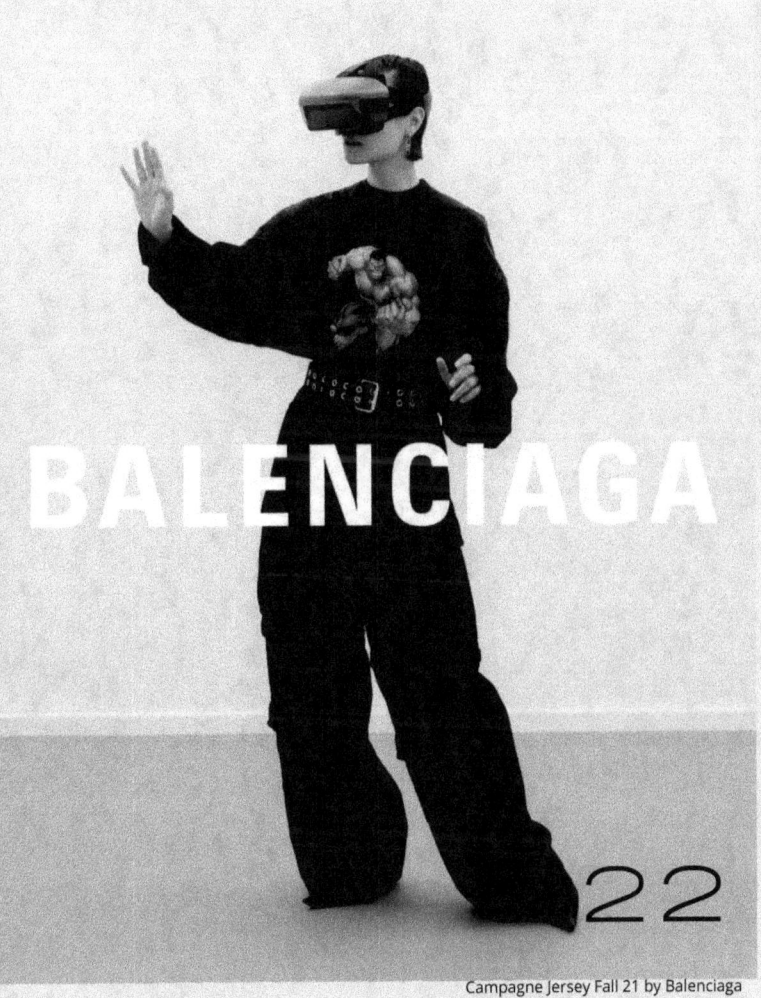

Campagne Jersey Fall 21 by Balenciaga

The brand has embraced digital, using innovative technologies for its fashion shows and communications, including augmented and virtual reality presentations.

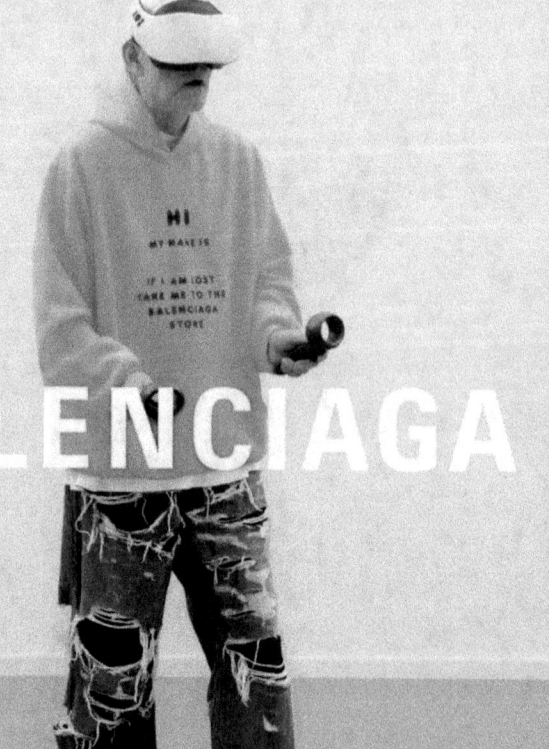

Campagne Jersey Fall 21 by Balenciaga

The models are immortalized by photographer Daniel Roché in the typical postures of an immersion in virtual reality, as if suspended, disoriented perhaps, between two fictional universes, IRL and VR.

Balenciaga in Augmented Reality: The Future of Luxury Unveiled

Sunday marked a bold turn for Balenciaga, under the creative direction of Demna Gvasalia, who presented its fall 2021 collection through an augmented reality runway show, immersing spectators in a futuristic luxury experience.

As the world adapts to a new digital normal, Balenciaga has innovated by sending a limited selection of media and professional buyers across the globe a virtual reality headset, accompanied by a QR code and an exclusive invitation for a virtual meeting on Sunday at 2 p.m.

This initiative, although impressive, was reminiscent of the technical challenges encountered during the first days of confinement, a period when videoconferences were often subject to connection problems and palpable stress. However, the experience offered by Balenciaga proved to be remarkably fluid and comfortable, once the helmet adaptation and charging phase was overcome.

The guests, VR headsets screwed on their heads as if they were the protagonists of a science fiction film, were offered a place in the front row of a Balenciaga fashion show of a new kind.

Using the scenography and visual codes of traditional shows, usually organized at the Cité du cinéma in Saint-Denis, this augmented reality presentation brilliantly demonstrated how technology can transcend physical barriers, offering a new dimension to the experience of fashion.

This Balenciaga augmented reality show not only marks an innovative moment for the fashion house; it also reflects a significant evolution in the way fashion seeks to interact with its audience in an increasingly digitalized world.

Balenciaga's immersive and avant-garde experience highlights the growing importance of technology in creating unique luxury experiences, paving the way for new forms of presentations in the fashion industry.

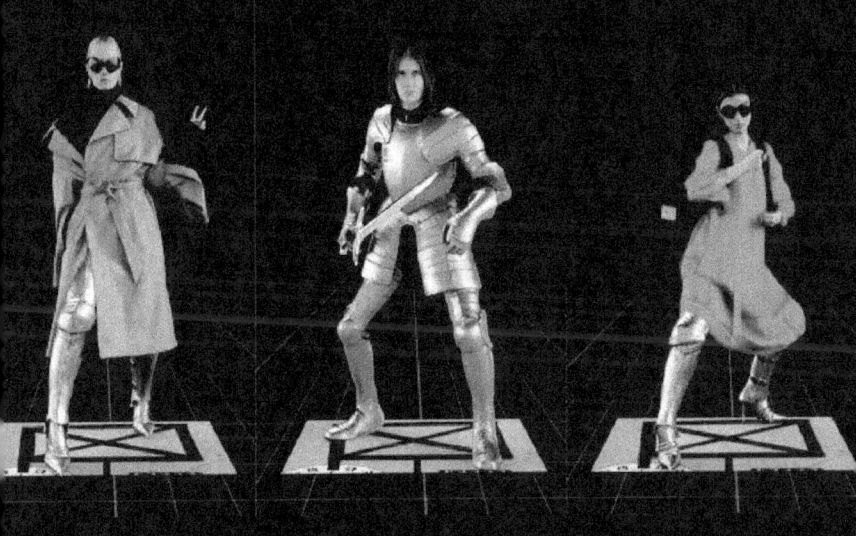

24

The models are immortalized by photographer Daniel Roché in the typical postures of an immersion in virtual reality, as if suspended, disoriented perhaps, between two fictional universes, IRL and VR.

Curiosities
Everything about Balenciaga

What is the story of Balenciaga?

1895
Birth of Cristóbal Balenciaga in Getaria, in the Spanish Basque Country.

1917
Cristóbal Balenciaga founded his Haute Couture House in San Sebastian, Spain.

1937
$Inauguration of the first Balenciaga boutique in Paris, 10 avenue George V.
Presentation of the designer's first collection, which was a great success with the press and customers.

1947
Creation of the first Balenciaga perfume: Le Dix.

1948
Creation of a second perfume: La Fuite des Heures.

1951
Creation of the Vareuse and Cocoon lines.

1952
Launch of the first boxy suits. Creation of the Parachute dress.

1953
The waist gains the hips, the silhouette is transformed.

1955
Creation of the first "I" tunic. Launch of the third Balenciaga perfume: Quadrille. Collaboration with Robert Goossens on a jewelry line.

1957
The clean lines of Balenciaga's creations continue to revolutionize fashion.
Sac dress, Bell and Peacock line.

1958
Creation of the Baby Doll dress and the gazar, a signature textile invented by the Abraham workshop for the couturier. The designer is decorated with the Legion of Honor.

1959
On suits, jackets are short and the waist is higher. Amphora line.

1961
Zurbarán-style evening dresses, duenna dresses and sumptuous negligees. Costume creation for the play Orphée by Jean Cocteau.

1963
Creation of the Sari dress. Launch of a range of boots, presented with matching sports suits, in collaboration with Mancini.
Collaboration with Roger Vivier on a collection of sandals.

1965
Creation of the Petal dress.

1968
Presentation of Cristóbal Balenciaga's last collection, before the designer retired to Spain after 30 years of innovation in the fashion world.

1972
Death of Cristóbal Balenciaga on March 24, 1972 in Javea, Spain. The creator is buried in the Basque Country, his native region.

1997
Appointment of Nicolas Ghesquière as Artistic Director of the House.

2001
Acquisition by Kering of Maison Balenciaga.

2004
Launch of the men's ready-to-wear and accessories collection.

2006
Balenciaga exhibition at the Museum of Decorative Arts, in Paris.

2011
Exposition « Balenciaga and Spain » au De Young Fine Art Museum de San Francisco.
Inauguration of the Cristóbal Balenciaga Foundation in Getaria, Spain.

2012
Exhibition "Cristóbal Balenciaga, fashion collector" at the Docks, Cité de la Mode et du Design, in Paris. Appointment of Alexander Wang as Artistic Director of the House.

2015
Appointment of Demna as head of artistic direction of the House.

2016
Presentation of the first men's fashion show for the spring-summer 2017 collection.

2021
Demna relaunches the Couture collection after a 50-year hiatus.

2022
Opening of the Couture boutique at the Maison's historic address in Paris, 10, avenue George V.

Who took over the Balenciaga house?

2001: acquisition of the house by the Italian brand Gucci, which will be integrated two years later into the luxury department of the PPR group, now named Kering. 2011: opening of the Balenciaga museum in the Basque Country. 2012: arrival of Alexander Wang as artistic director.

In 2001, the Balenciaga house experienced a major turning point with its acquisition by Gucci, one of the most prestigious Italian brands in the world of luxury. This acquisition signified not only a change of ownership but also a new strategic direction for Balenciaga. Two years later, in 2003, Gucci and, by extension, Balenciaga became an integral part of the luxury department of the PPR group, which would be renamed Kering in the following years. This move marked the beginning of a new era for Balenciaga, providing resources and an international network that allowed the brand to grow and expand globally.

2011 saw the inauguration of the Balenciaga Museum in the Basque Country, an initiative that highlights the importance of the founder, Cristóbal Balenciaga, and his legacy. This museum has become a place of pilgrimage for fashion admirers and for those interested in the history and influence of Balenciaga in the world of haute couture.

In 2012, Alexander Wang was named artistic director of Balenciaga, bringing with him a breath of fresh air and a modern perspective. Known for his minimalist approach and contemporary design sense, Wang has successfully married Balenciaga's heritage with avant-garde fashion elements. His appointment was seen as a bold step for the house, demonstrating its desire to continue to innovate while respecting the traditions that have made Balenciaga's reputation.

Under the Kering umbrella, Balenciaga has continued to expand, solidifying its position as one of the most influential and innovative fashion houses of the 21st century. The acquisition by Gucci and integration into the Kering group were key steps that allowed Balenciaga to expand its global reach and continue its evolution in a constantly changing industry.

Who wears Balenciaga?

Armenian-American sisters like to wear his creations and Kim Kardashian is the muse of the house. In 2021, Demna even accompanied the creator of SKIMS to the very selected Met Gala organized by the popess of fashion Anna Wintour.

Balenciaga, has become a go-to brand for many high-profile celebrities and influencers, including the Kardashian sisters, among whom Kim Kardashian is particularly notable. Balenciaga's appeal to these figures lies in its unique approach to fashion, which combines avant-garde design elements with a keen sense of modernity and innovation.

Kim Kardashian, as the face of the house, has often been seen wearing Balenciaga pieces, ranging from dramatic evening wear to the brand's iconic accessories. Her close relationship with Balenciaga and Demna Gvasalia was highlighted during the 2021 Met Gala, an annual event considered one of the most prestigious moments on the fashion calendar. During this event, organized by Anna Wintour, editor-in-chief of Vogue USA and leading figure in the fashion industry, Demna Gvasalia accompanied Kim Kardashian, highlighting not only their friendship but also the professional partnership between the star and the brand.

Who wears Balenciaga?

This moment at the Met Gala was particularly significant, as it illustrated Balenciaga's growing influence in the realm of high fashion and its role as the go-to choice of celebrities for the most scrutinized and high-profile occasions. Balenciaga's presence at the Met Gala, through figures such as Kim Kardashian, demonstrates the brand's ability to create clothing that captures attention and sets trends, while remaining true to a unique aesthetic that challenges traditional conventions of fashion.

Balenciaga's association with stars of Kim Kardashian's stature and commitment to pushing the boundaries of fashion design makes the brand a favorite among those looking to make a bold style statement. This synergy between Balenciaga and influential figures in the world of fashion and entertainment continues to strengthen the brand's status as an innovative leader in the luxury fashion industry.

What is Balenciaga's slogan?

One of the iconic slogans of Balenciaga under the direction of Demna Gvasalia is "Fashion is a Tool for Self-Expression". This slogan perfectly reflects Gvasalia's approach to fashion, where clothing is seen as a way for individuals to express their unique identity and belonging to a specific culture or subculture. Through its collections, Balenciaga encourages people to embrace their individuality and stand out in a world where fashion is often standardized.

Under Nicolas Ghesquière, Balenciaga explored futuristic and experimental themes, although the house did not specifically use a slogan during this period. However, the essence of his work could be summed up by the idea of "Reinventing Tradition". Ghesquière masterfully combined the legacy of Cristóbal Balenciaga with futuristic elements, pushing the boundaries of silhouette and textile.

"Fashion is a Tool for Self-Expression"

Cristóbal Balenciaga himself, although less focused on modern marketing as we know it today, left a legacy that could be encapsulated by the concept of "Elegance in Simplicity". Although not an official slogan, this phrase captures the essence of his designs, which found strength in purity of form and impeccable design, rather than excessive ornamentation.

It's important to note that, unlike other brands that may rely on slogans to define their image, Balenciaga has often let its designs speak for themselves. The brand used strong visual campaigns and bold fashion statements to communicate its vision.

That said, each period of Balenciaga's history, reflected through its successive artistic directors, could be associated with key themes or ideas that function as unofficial slogans, guiding the brand through developments in fashion and the society.

Where are Balenciaga clothes made?
Two of the Kering group's brands are exceptions to the rule: Saint Laurent and Balenciaga are both transparent, indicating "Made in France" and "Made in Italy" in their product sheets.

What are Balenciaga's values?
Cristobal Balenciaga founded Balenciaga on two strong principles: rigor and craftsmanship.

What is Balenciaga's style?
Balenciaga deconstructs the lines of the body and offers clean and refined cuts. His architectural vision of clothing involves a very selective use of fabrics: he favors blisters, velvet... The couturier even goes so far as to create new fabrics.

Which group does Balenciaga own?
A global luxury group, Kering brings together and grows a group of emblematic houses in fashion, leather goods and jewelry: Gucci, Saint Laurent, Bottega Veneta, Balenciaga, Alexander McQueen, Brioni, Boucheron, Pomellato, Dodo, Qeelin, Ginori 1735 , as well as Kering Eyewear and Kering Beauté.

What is Balenciaga's turnover?
Within the group, the label is close behind Bottega Veneta, itself behind Saint-Laurent and the figurehead Gucci. At the origin of these performances? Solid success in Asia. The turnover of its subsidiary in Shanghai reached 304 million euros last year, that of its Thai entity 196 million

What are François Pinault's brands?
Gucci, Saint Laurent, Bottega Veneta, Balenciaga, Alexander McQueen and Brioni: the Houses of Kering's Couture and Leather Goods division are recognized around the world for their exceptional know-how and their unique creative identity.

Where are Balenciaga shoes made?
the Triple S will now be produced in China and no longer in Italy as was the case before.

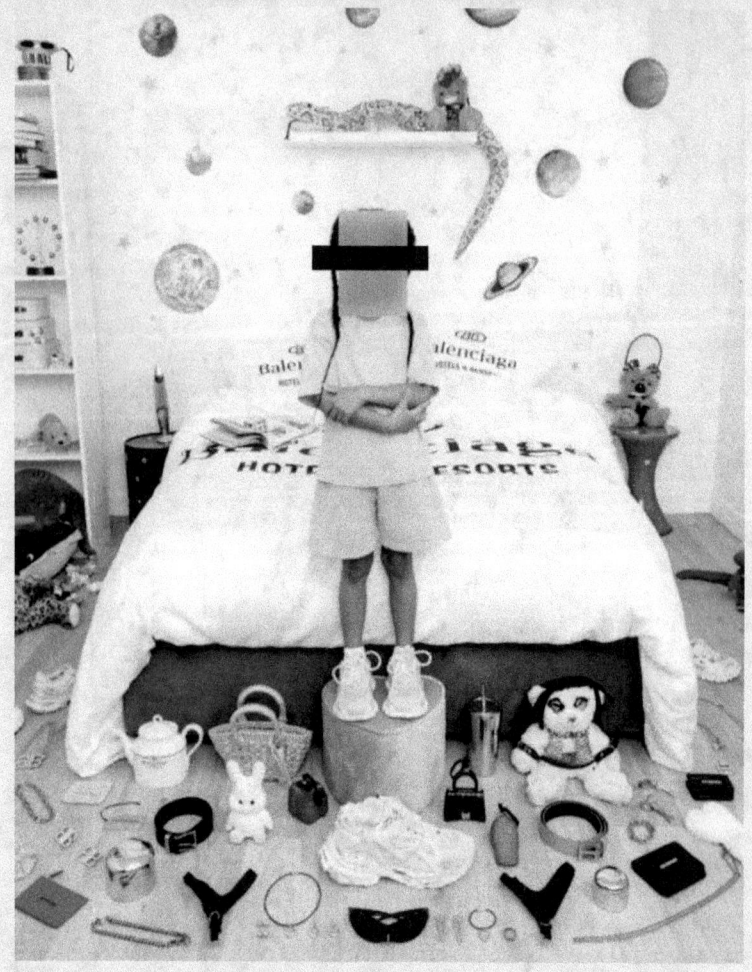

25

Balenciaga: the French brand in embarrassment

"What would luxury be without scandal?"

Luxury brands, including Balenciaga, are often the center of attention, not only for their creations and innovations but also for the controversies that can emerge around their advertising campaigns and marketing decisions. In the event that a brand like Balenciaga finds itself embroiled in controversy, including a campaign potentially featuring children in a provocative or inappropriate manner, it raises important questions about the ethical and social responsibilities of high fashion houses.

Luxury, with its aura of perfection and exclusivity, is not immune to scandals. Indeed, these incidents can sometimes serve as a stark reminder that behind the glamor and prestige lie complex decisions, with implications that can sometimes escape the original intentions of creators and marketers. Scandals can prompt brands to re-evaluate their communication strategies, strengthen their verification protocols and engage more deeply in reflection on the values they wish to convey.

However, "What would luxury be without scandal?" This question highlights an intriguing facet of the luxury fashion industry: its ability to bounce back and reinvent itself after controversies. Scandals, while undesirable, can sometimes catalyze change, pushing brands to innovate their approach and refine their brand identity. They can also spark vital public debate on important topics, leading to increased awareness and more responsible business practices.

While controversies can embarrass a brand and require careful public relations management, they can also serve as a starting point for renewal and reflection, helping to shape the future of luxury in a more conscious and informed way. thoughtful.

26

The brand has often been mentioned in **popular music and media**, becoming synonymous with luxury and avant-garde in contemporary culture.

Balenciaga in Pop Culture

Music artists, particularly in the hip-hop, R&B, and pop genres, have frequently incorporated Balenciaga into their lyrics and public appearances, using the brand as a hallmark of success, wealth, and a strong sense of purpose. fashion. These endorsements not only serve to express a taste for luxury, but also to highlight the importance of the brand in the cultural dialogue about identity, belonging and aspiration.

Balenciaga, under the creative direction of designers like Demna Gvasalia, has captivated a young, hip audience with designs that fuse streetwear with luxury. This approach has cemented the brand's position as being at the heart of contemporary fashion trends, making it a common topic of conversation in media and popular culture.

Balenciaga's collaborations with artists, celebrities and other brands have also contributed to its ubiquity in the media. These partnerships have often resulted in exclusive capsule collections, notable appearances at haute couture events, and highlights on social media, amplifying its cultural impact.

By becoming synonymous with luxury and avant-garde, Balenciaga has not only solidified its status as a leading fashion brand, but also established a deep connection with contemporary culture.

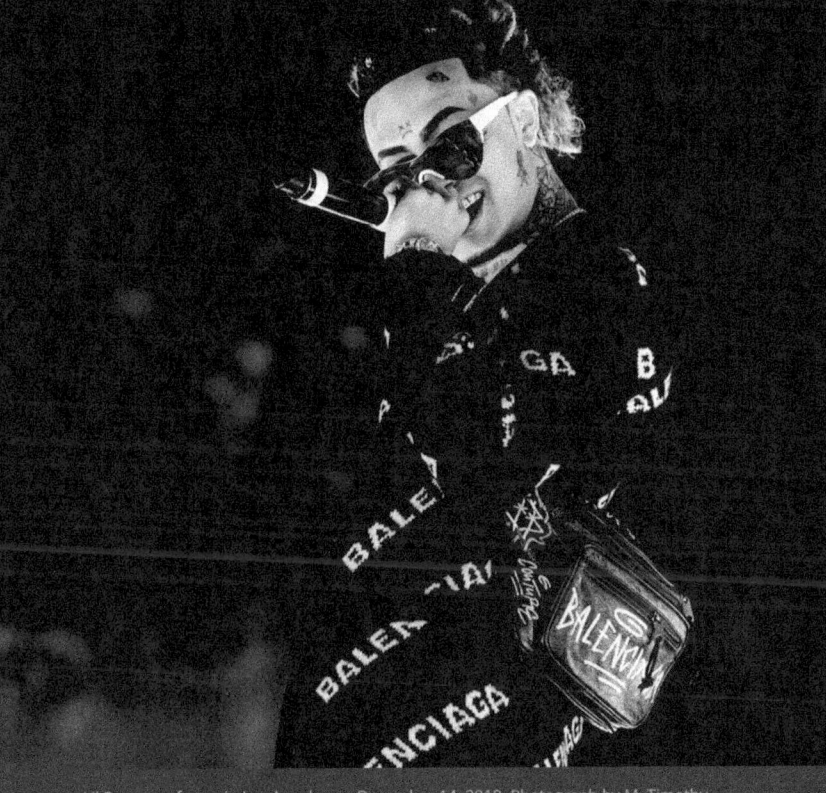

Lil Pump performs in Los Angeles on December 14, 2019. Photograph by M. Timothy Norris/Getty Images

27

"The freshest clothes are no longer on department store shelves, they are on fashion runways or in hyper-exclusive collaborations that most people don't have access to"

history

THE
Balenciaga
EDITING

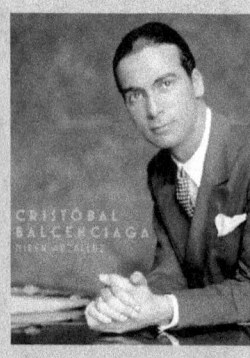

couturier

Cristóbal Balenciaga, the founder of the fashion house Balenciaga, is often considered one of the most revolutionary and talented couturiers of his time.

Born in 1895 in Getaria, a small town in the Basque Country of Spain, Balenciaga began his journey in fashion at a young age, training under his mother, a seamstress. His exceptional talent and determination quickly propelled him to the forefront of haute couture. In 1919, he opened his first boutique in San Sebastián, Spain, before moving to Paris in the 1930s, where he established his eponymous brand.

28

Balenciaga has engaged in various artistic and cultural projects, collaborating with artists, museums and cultural institutions to create unique experiences.

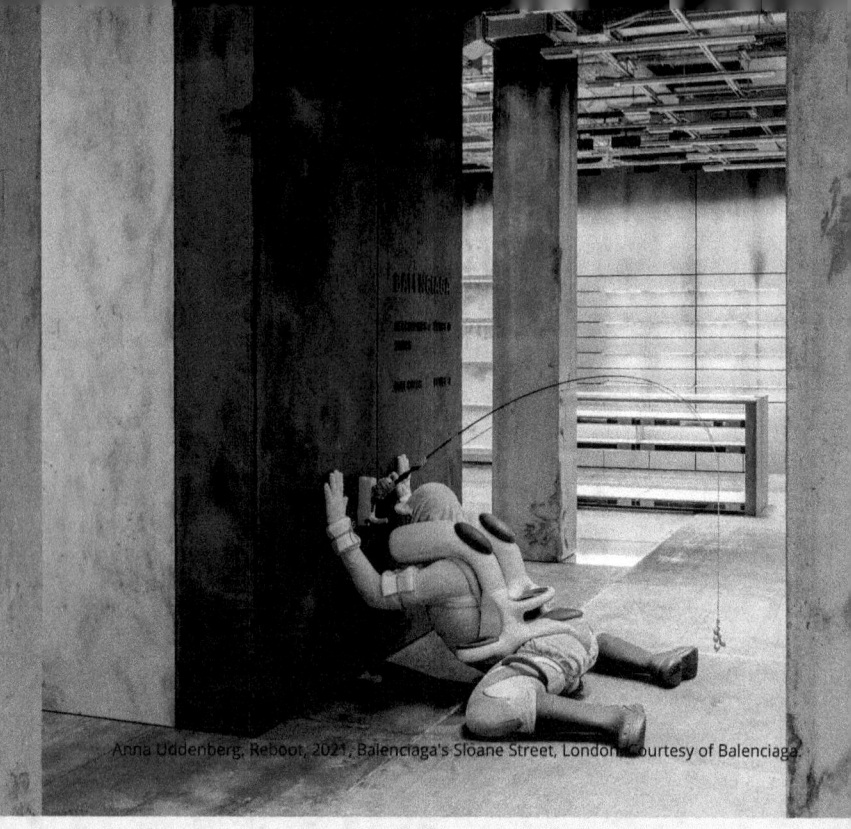

Anna Uddenberg, Reboot, 2021, Balenciaga's Sloane Street, London. Courtesy of Balenciaga.

29

Balenciaga collaborated with Swedish artist **Anna Uddenberg** for an advertising and in-store campaign, using custom sculptures created from brand surplus and shod in innovative Balenciaga Crocs. One of the works, "Tanya", depicts a woman near a stroller in the ruins of an NSA station in Berlin, to celebrate the launch of Croc Boots and Crocs Madame in 2021. In 2022, the project " Art in Stores" brought these sculptures to Balenciaga boutiques in New York, London, and Milan, showcasing the new Crocs collections.

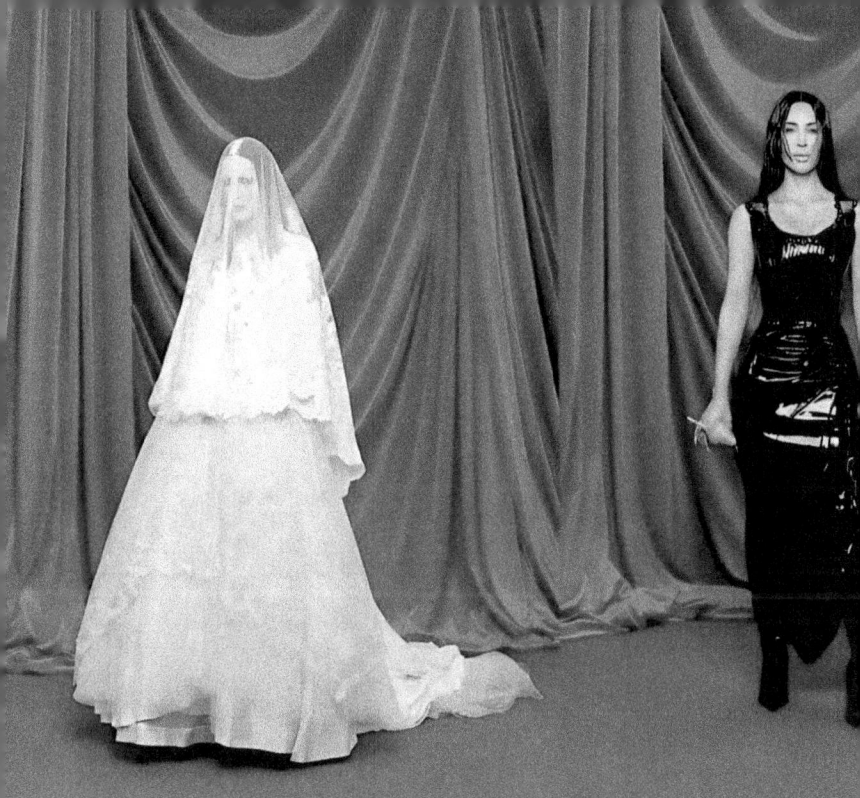

Balenciaga Staged at Grand Fashion Theater for Spring 2024

30

The brand has worked to increase diversity and inclusiveness in its advertising campaigns and runway shows, reflecting a commitment to the representation of all communities.

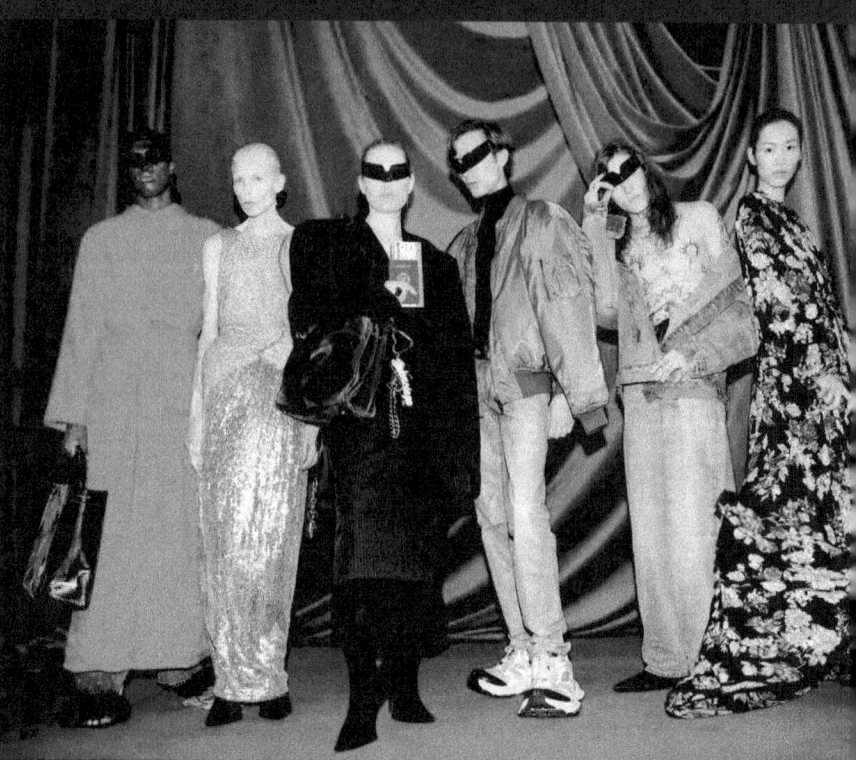

Balenciaga Staged at Grand Fashion Theater for Spring 2024

31

The invitation to the Balenciaga show for the spring-summer 2024 collection, during Paris Fashion Week, already announced a unique experience: a sewing manual detailing the fundamentals of garment design, such as "Construction. Bias. Hem." On October 1, the show fully lived up to these preliminary expectations. In an atmosphere shrouded in sumptuous red curtains that adorned the walls, the voice of Isabelle Huppert giving sewing instructions added a theatrical touch to the event. Models, celebrities, and those close to the designer paraded in this world rich in drapes, highlighting the craftsmanship and innovation of the collection.

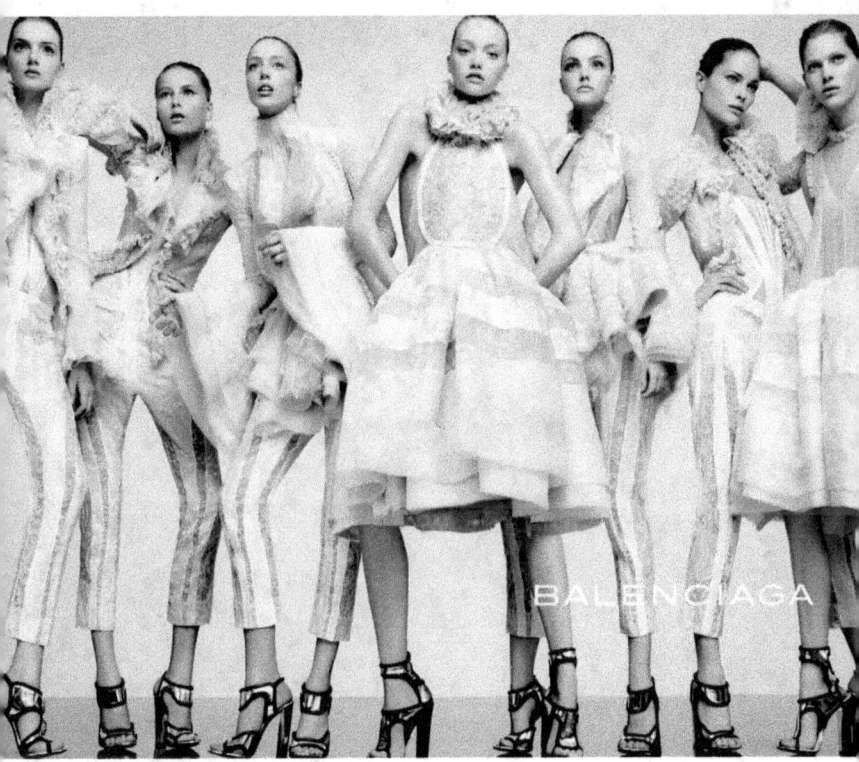

Balenciaga, spring-summer 2006

32

Although based in Paris, **Balenciaga pays homage to its Spanish roots** through some of its collections, reflecting the cultural influences of its founder.

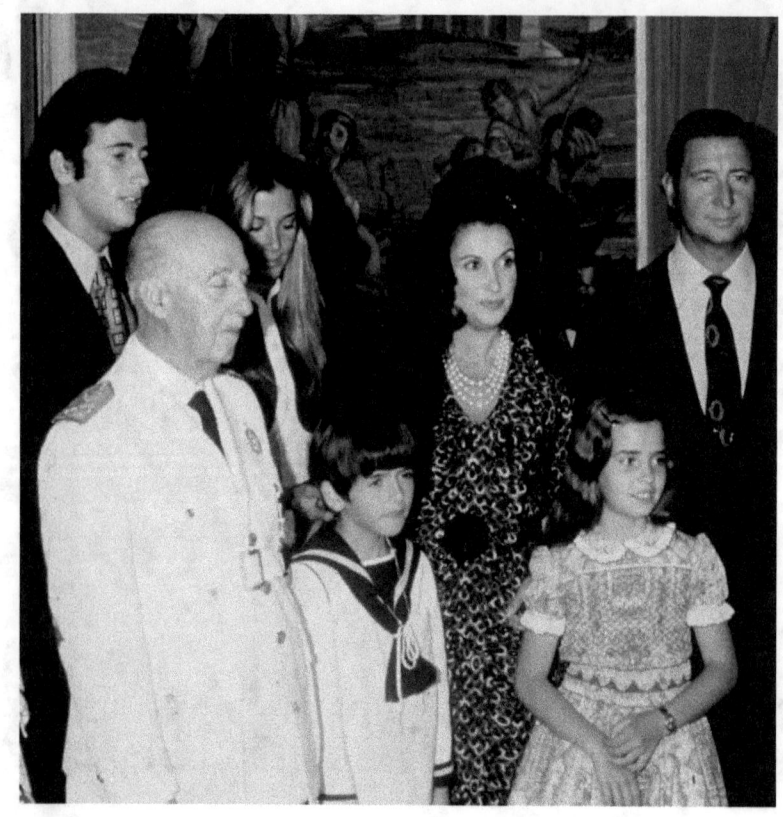

33

Cristóbal Balenciaga designed dresses for the family of Spanish dictator **Francisco Franco**, despite criticism. This shows the importance and status of the brand even in controversial political contexts.

Balenciaga has been involved in various charitable and social initiatives, showing a commitment to important causes on a global scale.

WFP
World Food Programme

34

SUPPORTED BY
BALENCIAGA

Responsibility and Social Commitment

Balenciaga, beyond its iconic status in the world of high fashion, has taken concrete steps to engage in charitable and social initiatives, illustrating a deep commitment to corporate social responsibility. One of Balenciaga's most notable moves in this area has been its partnership with the United Nations' World Food Program (WFP).

In 2018, the brand launched a capsule collection from which part of the profits were intended to support WFP's efforts in the fight against world hunger. This collaboration aimed not only to raise funds but also to raise awareness on global food security issues.

Additionally, Balenciaga responded quickly to humanitarian and environmental crises. For example, in response to the devastating fires in Australia in 2020, Balenciaga created T-shirts and sweatshirts with 100% of the profits donated to an organization dedicated to fighting wildfires in Australia. This initiative showed the brand's commitment to contributing to urgent causes and mobilizing its community for support.

Balenciaga has also become involved in the fight against COVID-19. The fashion house responded to hospitals' call for help by producing and distributing protective masks and gowns for healthcare workers, leveraging its production workshops to help alleviate the shortage of medical equipment. Individual protection.

These actions reflect Balenciaga's desire to use its platform and resources to have a positive impact beyond fashion. Balenciaga's involvement in charitable and social initiatives demonstrates that the brand views fashion as a means of expression but also as a tool for social change, highlighting the importance of civic engagement in the fashion industry. luxury.

35

Cristóbal Balenciaga was known for being extremely private, avoiding public appearances and interviews. This mystique added to the aura of the brand and made Balenciaga an almost mythical figure in the fashion world.

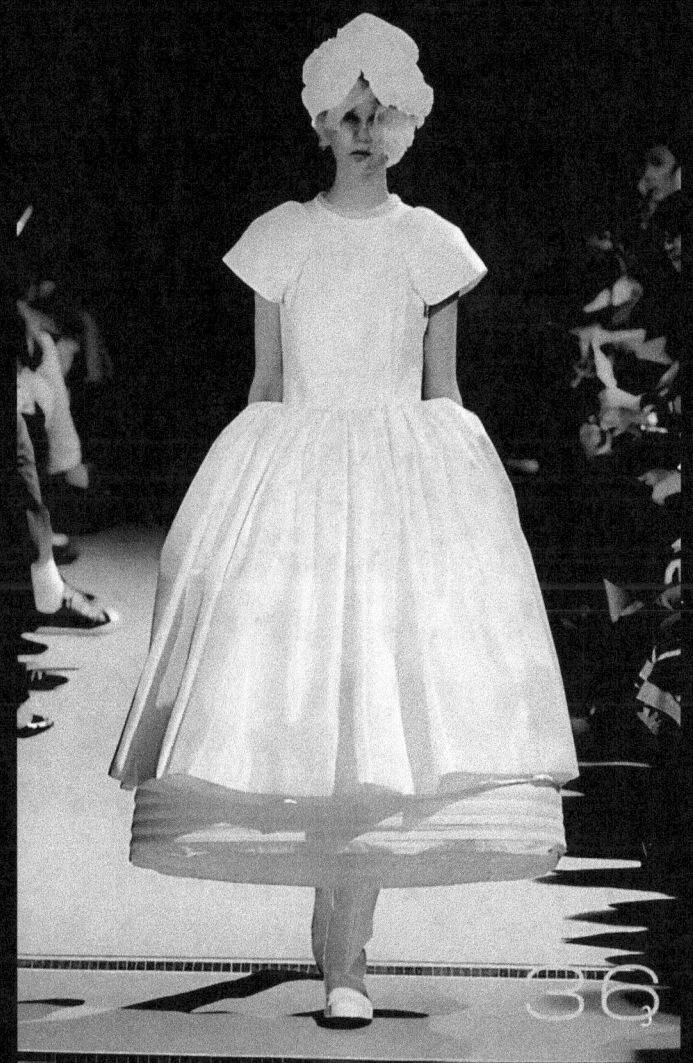

Balenciaga has had a notable influence on **Japanese fashion**, including designers like Rei Kawakubo of Comme des Garçons.

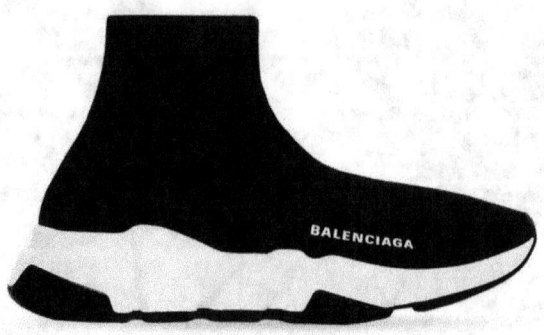

Speed Recycled sneaker in black recycled mesh with white and black outsole

37

Speed sneakers, with their unique sock-shaped design, set a global trend and have been copied by many other brands, demonstrating Balenciaga's influence on contemporary fashion.

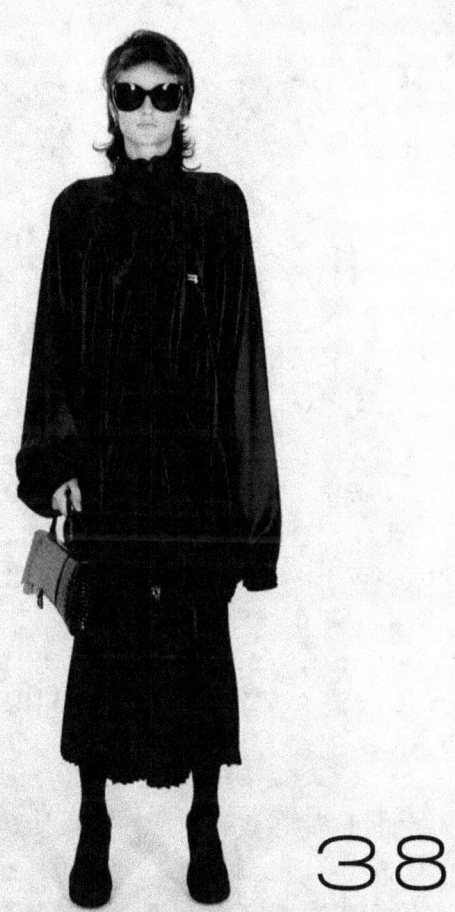

The Balenciaga spring-summer 2021 pre-collection

38

Balenciaga was one of the first to introduce **unisex collections**, blurring the lines between men's and women's clothing and advocating more inclusive and flexible fashion.

Balenciaga and the Unisex Revolution

Balenciaga, under the avant-garde vision of its successive artistic directors, has played a pioneering role in fashion's evolution towards a more inclusive and non-binary approach. By introducing unisex collections, the brand has crossed traditional boundaries, challenging the conventions that define men's and women's clothing. This innovative approach is not only a reflection on aesthetics; it also embodies a commitment to a vision of fashion that celebrates the diversity and fluidity of identities.

By deliberately blurring the lines between genders, Balenciaga encouraged a questioning of social norms and provided a space where personal expression is not limited by rigid categories. Balenciaga's unisex collections offer pieces that can be worn by everyone, featuring silhouettes, fabrics and patterns that transcend traditional gender expectations. This approach allows each individual to own clothing in a unique way, promoting an open dialogue about identity and self-expression through fashion.

Balenciaga's initiative to present unisex collections is part of a broader movement within the fashion industry, where more and more designers and brands are seeking to make fashion accessible and relevant for everyone, regardless of the kind. By adopting a more inclusive and flexible fashion, Balenciaga is helping to shape a future where fashion serves not only to dress the body but also to celebrate the richness of the human experience in all its diversity.

Balenciaga's unisex collections aren't just a passing trend; they represent an important step towards a more nuanced and inclusive understanding of fashion. Through this approach, Balenciaga continues to define the contours of a fashion world where innovation goes hand in hand with inclusiveness, offering everyone the freedom to define and express their identity through the prism of haute couture.

The Balenciaga spring-summer 2021 pre-collection

39

In the world of luxury, the unisex collection symbolizes a major evolution towards a more inclusive and flexible approach to fashion, challenging traditional gender norms. Renowned brands like Balenciaga have taken the lead in deliberately blurring the lines between men's and women's clothing, offering pieces that celebrate diversity and individuality, while challenging convention and promoting equality through the prism luxury fashion.

BALENCIAGA FALL 21 COLLECTION 013 - 050

GEORGIE

- TROMPE-L'OEIL LEGGINGS
- KILT MINI SKIRT
- FITTED TURTLENECK
- PARKA
- CHEVALIER 110MM OVER-THE-KNEE BOOT
- MASK BUTTERFLY SUNGLASSES
- MESSENGER MEDIUM TOTE WITH STRAP
- TOOLBOX PHONE CASE
- FLUFFY BUNNY EARPODS HOLDER WITH STRAP

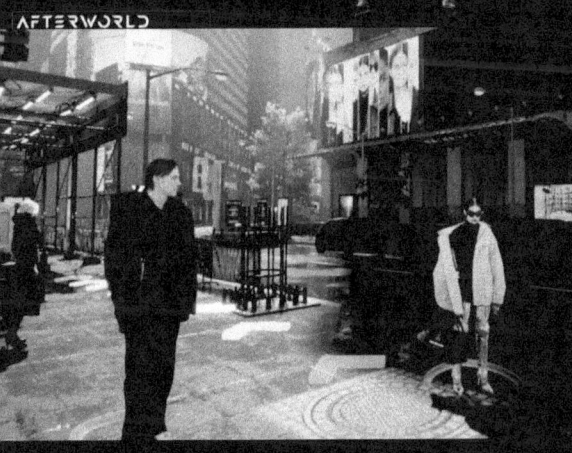

40

Under the direction of Demna Gvasalia, Balenciaga presented a collection via a video game titled **"Afterworld: The Age of Tomorrow"**, a first in the high fashion industry, integrating fashion into a virtual reality environment.

BALENCIAGA | 81

"Afterworld: The Age of Tomorrow"

Under the creative leadership of Demna Gvasalia, Balenciaga took a revolutionary step in the high fashion industry by launching "Afterworld: The Age of Tomorrow" in 2020. This initiative marked a turning point for the fashion house, merging clothing creation with cutting-edge technology. This video game, designed as a platform to present the fall 2021 collection, immersed viewers in a journey through a dystopian virtual reality environment, offering a futuristic and immersive vision of fashion.

The game is set in the year 2031, offering players an exploration through different worlds, each revealing key pieces of the collection in varied scenarios that blend the past, present and future. This unique storytelling approach has allowed Balenciaga to present its designs in an innovative way, engaging the audience in an interactive experience that goes beyond the traditional confines of a fashion show.

"Afterworld: The Age of Tomorrow" is not only notable for its pioneering format; it also illustrates Balenciaga's commitment to issues such as climate change, technology and social transformation, themes which are subtly integrated into the game. This collection and its virtual presentation highlight Gvasalia's forward-thinking vision for Balenciaga, highlighting fashion's ability to innovate and inspire beyond clothing design, addressing a generation of consumers who are connected and aware of the challenges of the future.

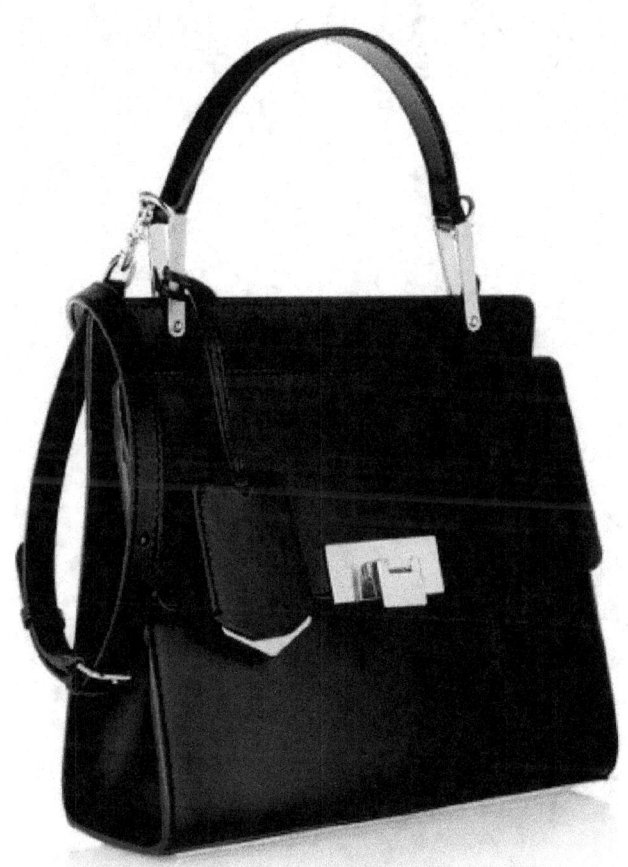

41

Balenciaga's **"Le Dix"** bag, introduced in the 1950s, has become a timeless classic. Its name comes from the number of the first Balenciaga boutique in Paris, located at 10, avenue George V.

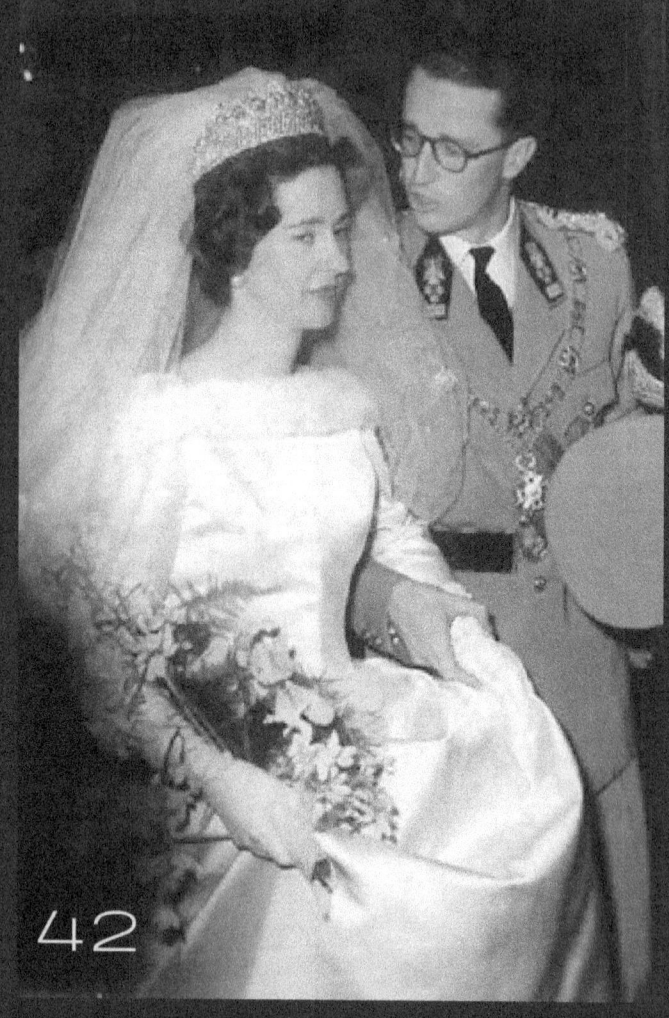

42

In 1960, Balenciaga designed the wedding **dress of Queen Fabiola of Belgium for her royal wedding**. This elegant dress has been acclaimed worldwide for its style and elegance.

43

The launch of the new Balenciaga sneaker line, called **Paris Sneakers**, is causing panic on social networks. And its artistic director to once again push the limits of creativity... And irony?

FASHION SHOW

CATEGORIES
Evening wear Fashion
Women's clothing

www.collections.vam.ac.uk

SPRING/SUMMER
1952

ARTIST/CREATOR
BALENCIAGA, CRISTÓBAL (CREATOR)
BUCOL (TEXTILE DESIGNERS)

HISTORY OF
OBJECTS

Created in 1952 and 1960 an evening dress and a coat. The dress, in nylon organza with velvet polka dots, and the coat in heavy satin. These pieces, gifts from Mrs. Catherine Hunt and Baroness Alain de Rothschild, bear witness to the subtle art of Balenciaga at the V&A museum.

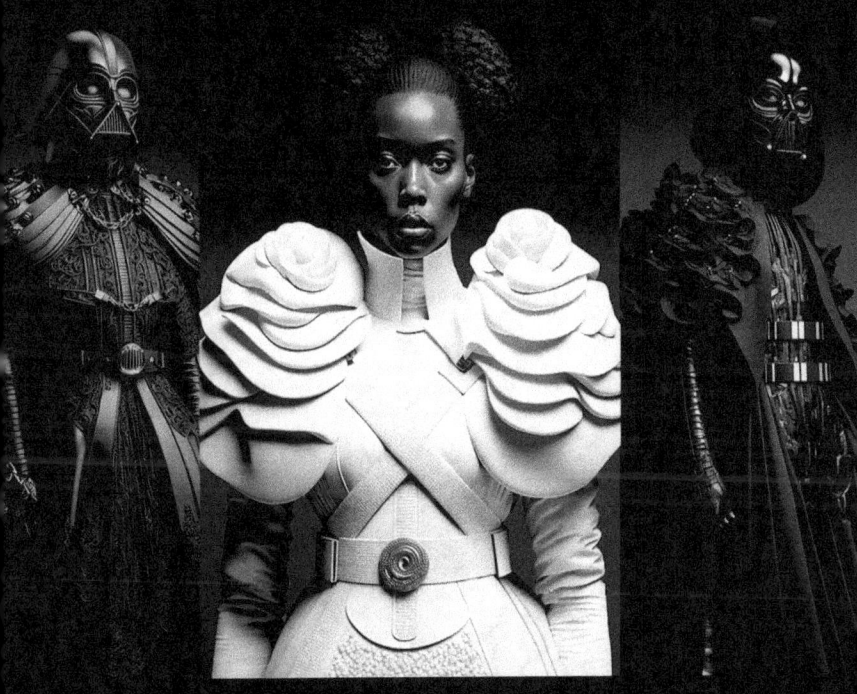

Photography: Rodo Morfin

44

In 2015, Balenciaga launched a collection inspired by "**Star Wars,**" showcasing its skill at incorporating elements of popular culture into its high fashion designs.

When AI Reinvents Fashion and Science Fiction

Rodo Morfin, founder of Morfosis, a digital artist collective based in Mexico, explores the boundaries of artistic creation at the intersection of fashion and science fiction. Using Midjourney AI to generate images, he creates hybrid works that merge the Star Wars universe with Balenciaga's distinctive style. Diagnosed with ADHD as a child, Morfin chose to follow an unconventional path, inspired by the creative legacy of his designer parents. His passion for transforming ideas into visual art led him to experiment with artificial intelligence, seeking to create simple but powerful images that blend the digital with reality.

In his latest series, Morfin marries the aesthetic of Star Wars' Imperial Forces with the elegance of Balenciaga, harnessing AI to accelerate and enrich his creative process. This approach is part of his fascination with collaborations between brands and the way in which they can redefine aesthetic universes. The artist uses the Midjourney app, combined with Discord, to direct the AI with detailed concepts, enabling a rich and complex visual interpretation that incorporates techniques borrowed from various artistic fields.

This experiment by Morfin opens new avenues for the integration of fashion and popular culture into digital art, asking questions about the future of creative collaborations and the potential of AI in the artistic field.

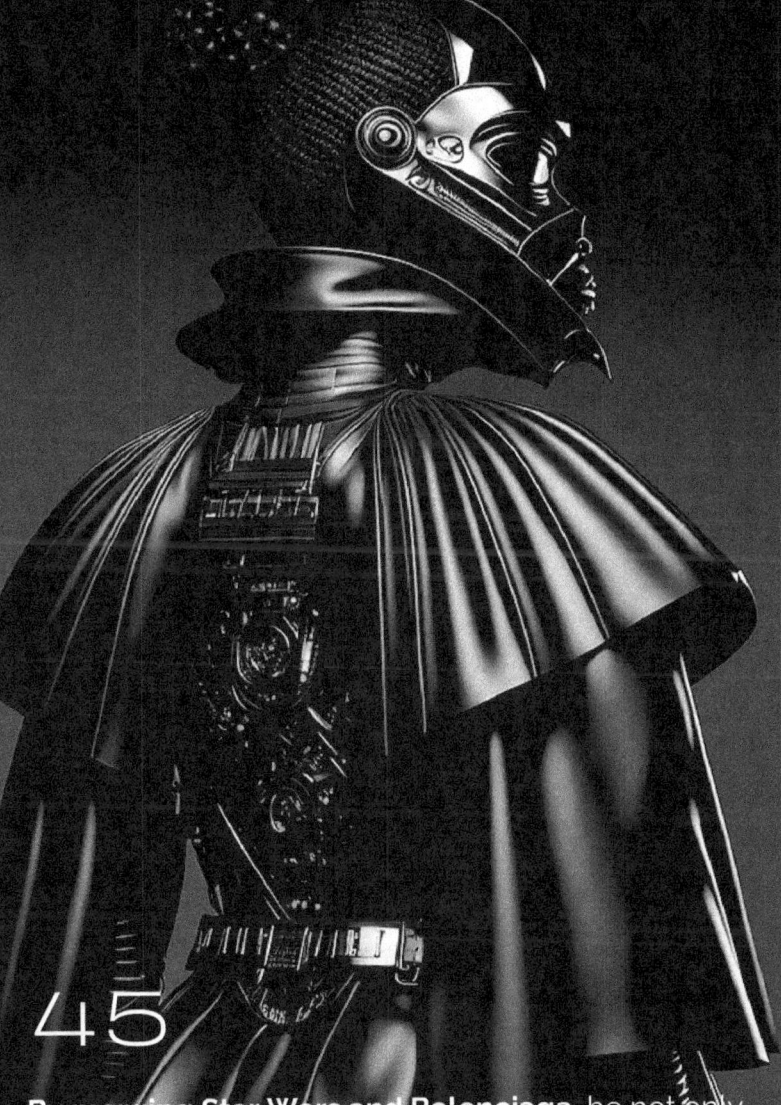

45

By merging Star Wars and Balenciaga, he not only creates captivating pieces; it also invites us to reflect on the infinite possibilities offered by technology in expanding creative horizons.

Photography: Rodo Morfin

53

BALENCIAGA SHOP OF HISTORY

REVOLUTION IN LUXURY FASHION

In the dynamic landscape of luxury fashion, Balenciaga shoes have established themselves as a symbol of modernity and innovation.

Since the introduction of iconic models such as the Triple S and Speed sneakers, the brand has redefined the standards of contemporary aesthetics in the world of footwear.

These creations, characterized by their bold designs and voluminous silhouettes, merge the comfort of streetwear with the elegance of luxury.

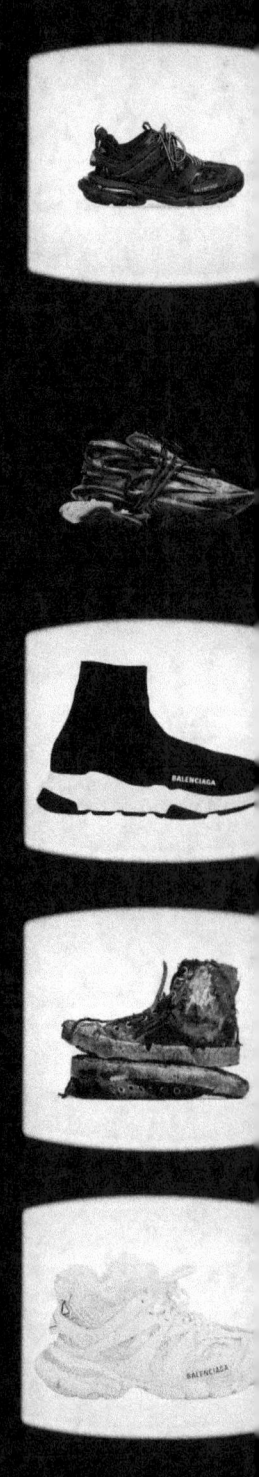

BALENCIAGA
PARIS

46

Under Gvasalia, **Balenciaga's logo was reinvented** to take on a more modern, minimalist look, reflecting the brand's evolution toward a more contemporary aesthetic.

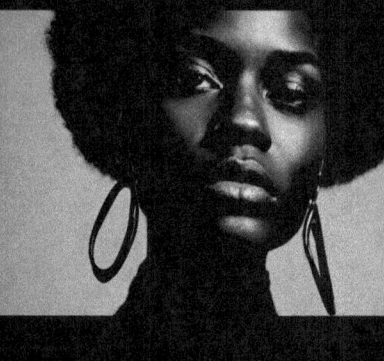

moment

photoshoot
Balenciaga

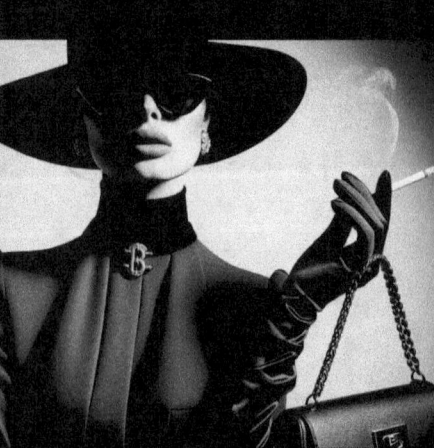
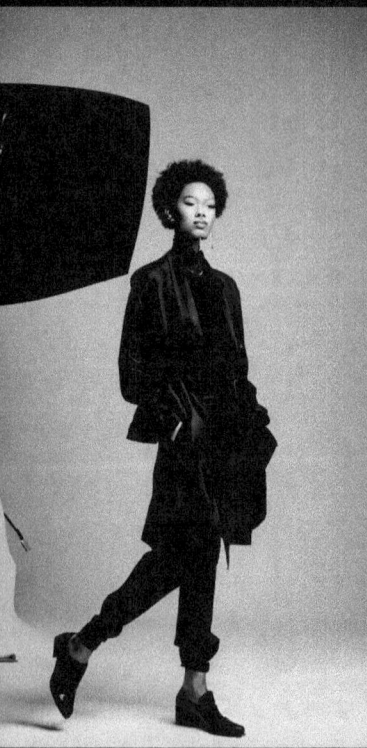

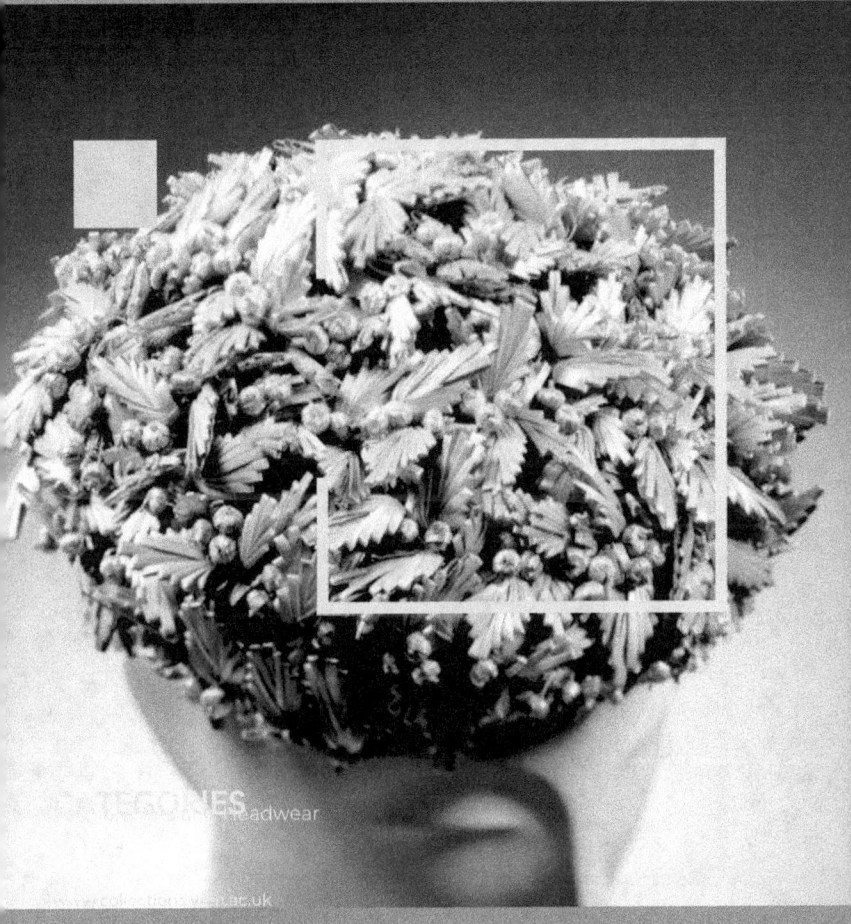

CALIFORNIA(MADE)
1950
PLACE OF ORIGIN PARIS (REALIZED)

ARTIST/CREATOR

BALENCIAGA, CRISTÓBAL (CREATOR)

HISTORY OF
OBJECTS

Worn by Martita Hunt, the British actor. Martita Hunt (1900-1969) was a British stage and screen actress, best known for her 1946 portrayal of Miss Havisham in David Lean's film version of "Great Expectations".

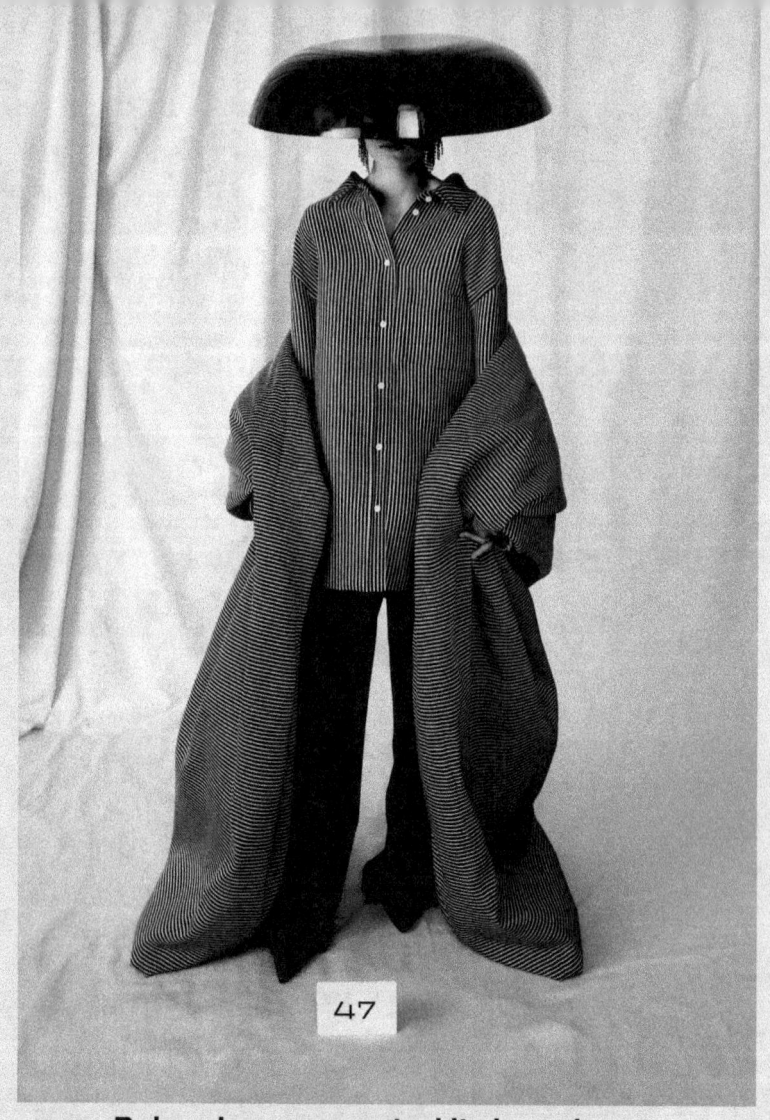

Balenciaga presented its brand new Haute Couture collection in Paris, 53 years after the one imagined by Cristóbal Balenciaga himself. A strong desire that emanates from artistic director Demna Gvasalia who has nurtured this wish since 2019.

Balenciaga Hats

Balenciaga hats are not simple accessories, but works of art in their own right that have left their mark on fashion history. Under the direction of Cristóbal Balenciaga, these headwear transcended their primary function to become symbols of sophistication and innovation. Balenciaga, considered the master of couture, had a particular talent for creating hats that perfectly complemented his clothing designs, adding an extra dimension to the overall look.

In the 1950s and 1960s, a period when haute couture reigned supreme, Balenciaga introduced hats in varying shapes, sizes and materials, from small, understated fascinators to sumptuous wide-legged cloche hats. Each piece reflected his avant-garde approach to fashion, where experimentation with volumes, lines and textures was at the heart of his creative process.

Balenciaga's hats were often characterized by their elegant minimalism, sometimes embellished with a bold touch or subtle detail, such as a delicate veil, a sculptural bow or an unusual pattern, which captivated the eye and sparked admiration .

These creations were not just fashion accessories, but style statements that highlighted the unique identity of the Balenciaga woman. They embodied a blend of grace and strength, reflecting Balenciaga's philosophy that true elegance lies in simplicity. The impact of Balenciaga hats extends beyond their era, influencing generations of hat designers and remaining a source of inspiration for contemporary fashion.

Over the decades, Balenciaga hats have maintained their iconic status, symbolizing the pinnacle of luxury and craftsmanship. They remain a testament to the ingenuity and creative genius of Cristóbal Balenciaga, a couturier whose legacy continues to enrich the world of fashion.

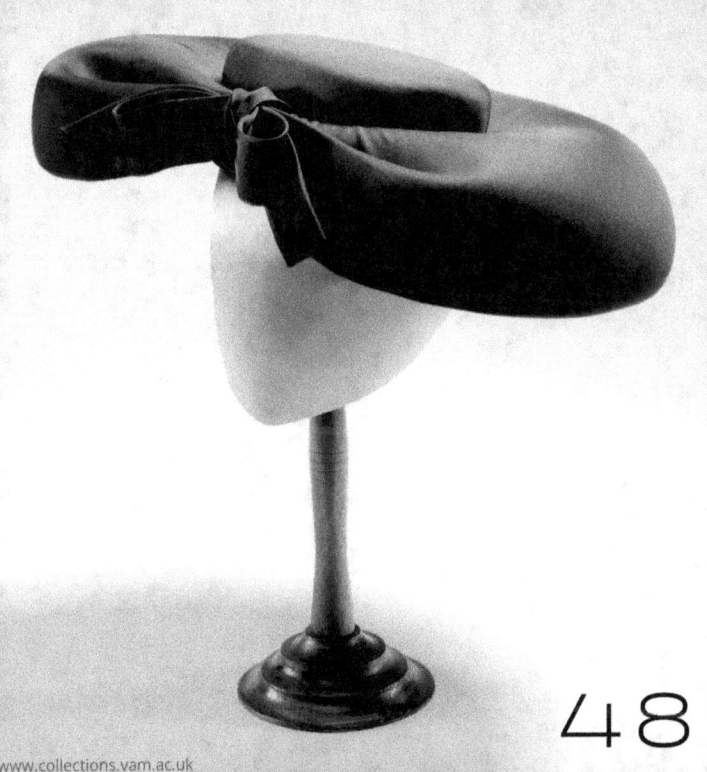

www.collections.vam.ac.uk

48

California. 1955 (directed)
"Balenciaga hats are an integral part of its fashion," reported the French fashion magazine Jardin des modes in 1961. They ensure "the balance of volumes and the perfect finish of the silhouette."

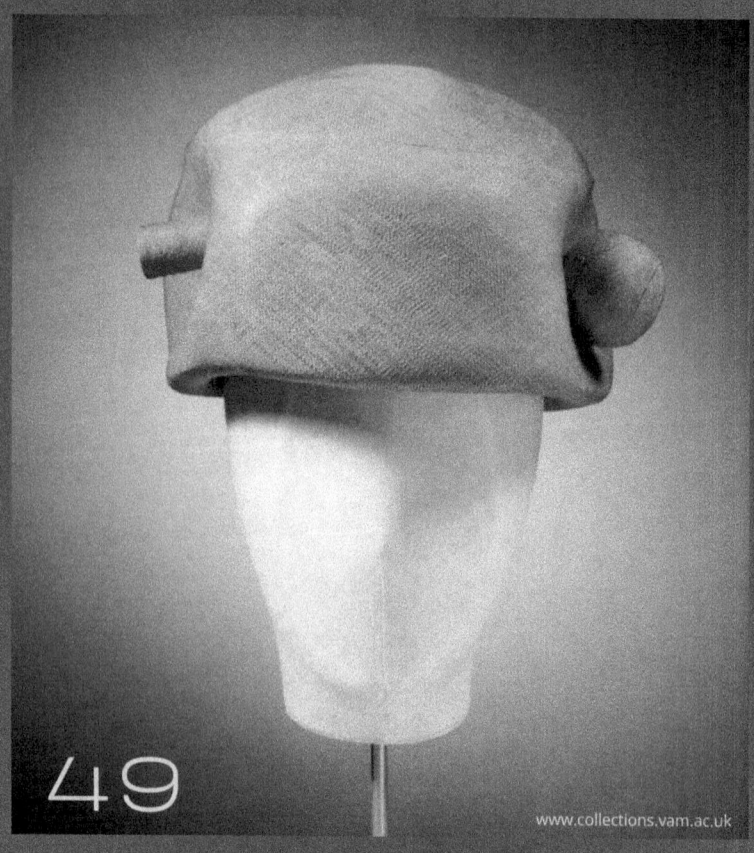

1963 (realized)

This item is part of the collection of Mrs Fern Bedaux, donated to the museum by Miss E Hanley, Mrs Bedaux's heiress and niece. Ms. Bedaux regularly bought her entire wardrobe from Balenciaga and the collection was very extensive; some were kept by Miss Hanley, others sent to the Costume Museum in Bath; and some have been received by the V&A.

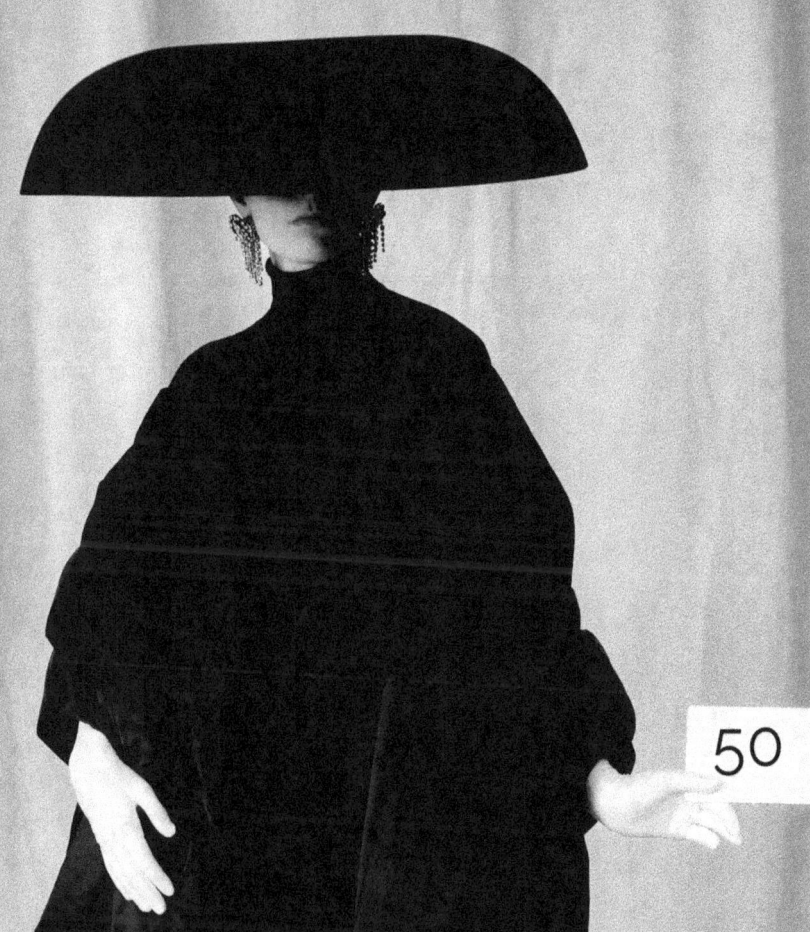

50

Fairly conventional ensembles were often paired with a striking hat that elevated the ensemble and made it appear edgier. The customer could purchase the entire set or leave the hat if it was too bold. Hat designs were as fiercely protected as those of dresses. The police commissioner stamped the official sketches of the hats to protect them from copying.

On Wednesday July 7, 2021, the house of Balenciaga presented its first haute couture collection since its founder, Cristobal Balenciaga, closed the doors of his design studio in 1968.

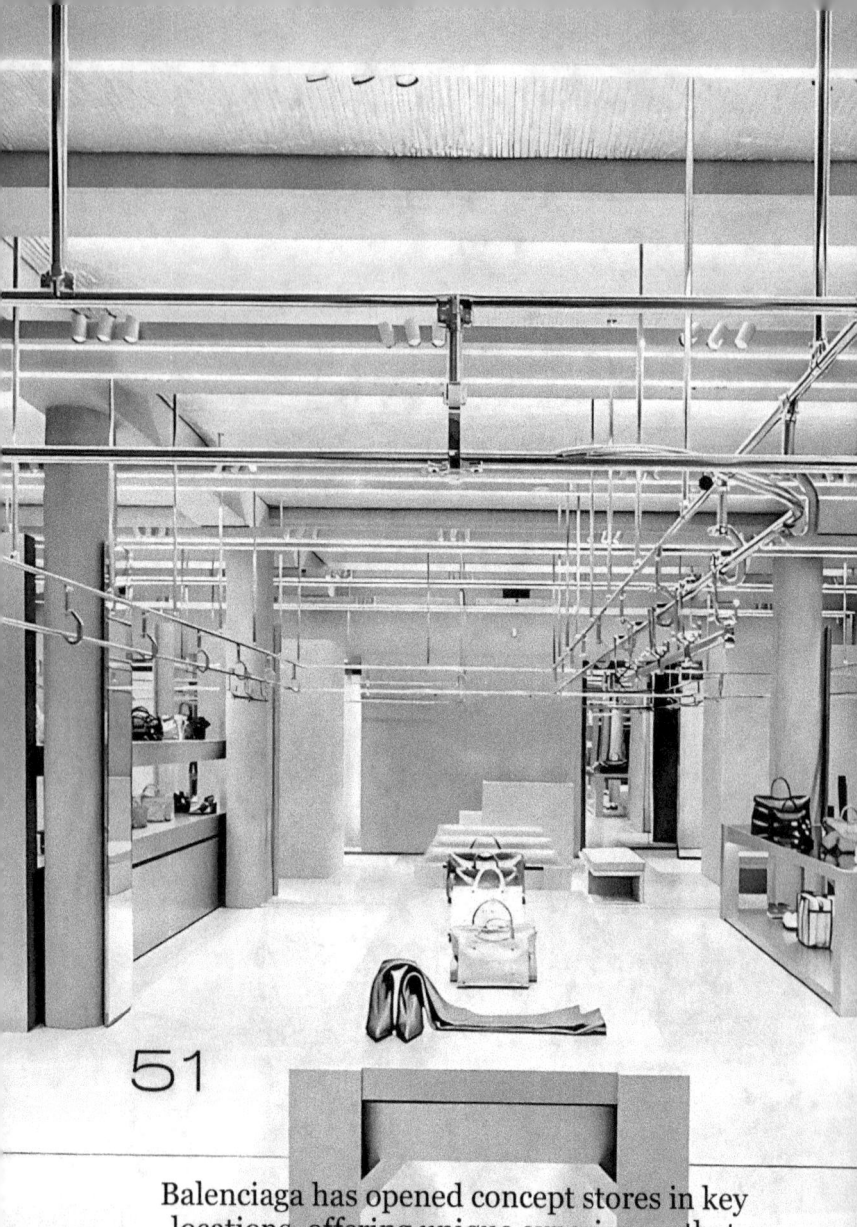

51

Balenciaga has opened concept stores in key locations, offering unique experiences that reflect the brand's identity and avant-garde aesthetic.

black is back ·&· ——○○○—— ·3· **Best style**

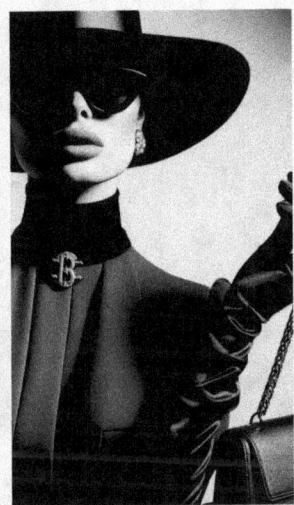

balenciaga

BLACK MODE THE FASHION

the choice of black – often considered the epitome of elegance and mystery – is an iconic signature that transcends ephemeral trends. This timeless color, a symbol of sophistication and power, is skillfully used by the brand to create pieces that combine depth and subtlety, reflecting an artistic vision where black becomes a canvas for the expression of creativity and style.

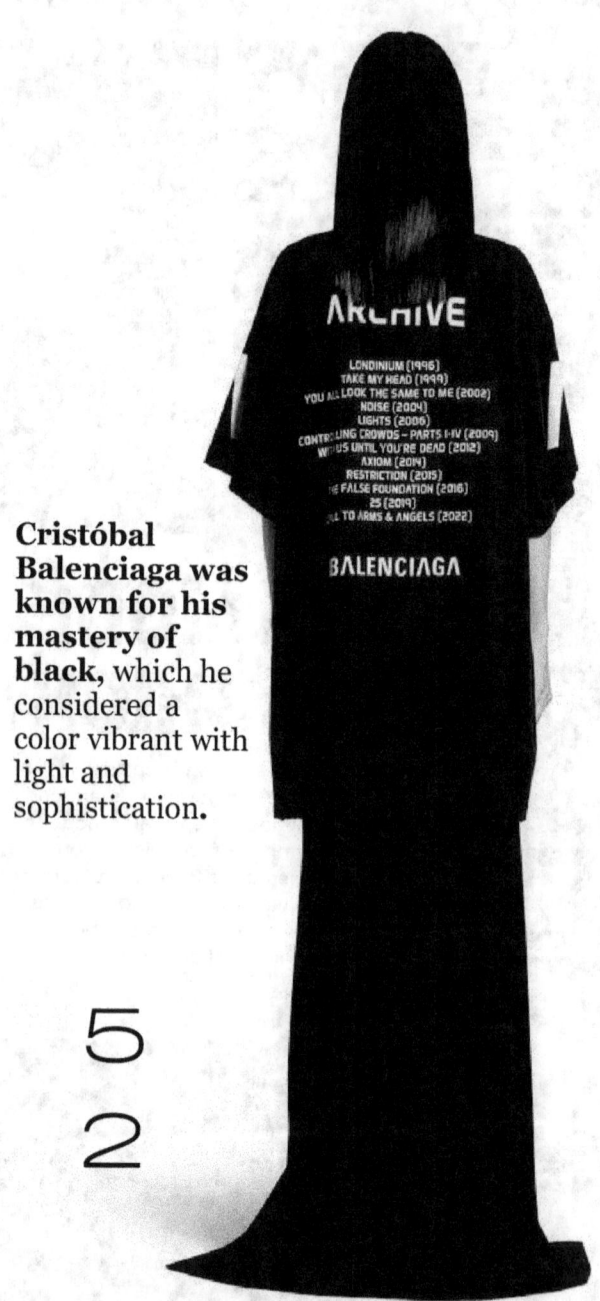

Cristóbal Balenciaga was known for his mastery of black, which he considered a color vibrant with light and sophistication.

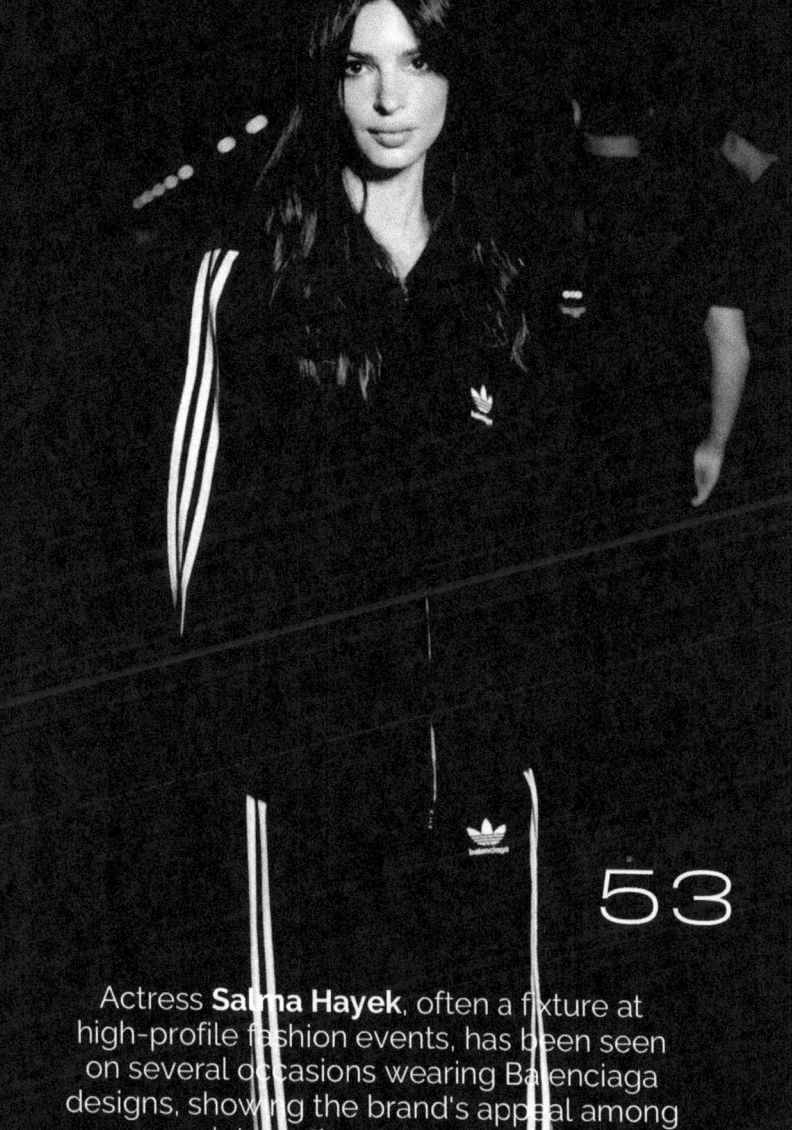

53

Actress **Salma Hayek**, often a fixture at high-profile fashion events, has been seen on several occasions wearing Balenciaga designs, showing the brand's appeal among international actresses.

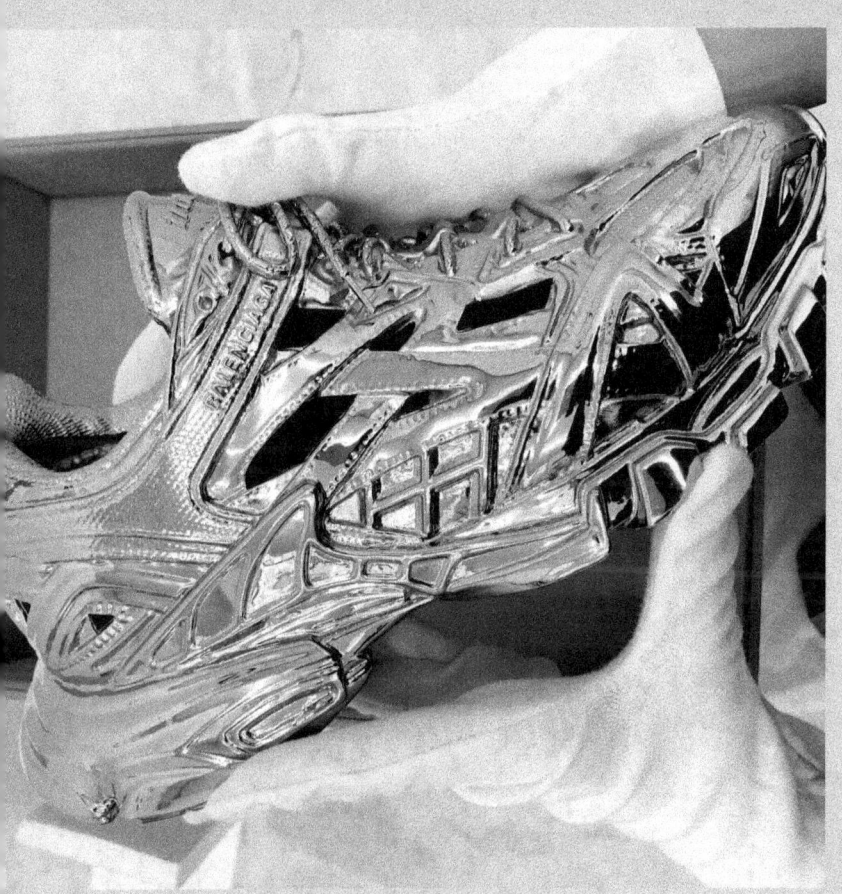

55

Under Gvasalia, **Balenciaga had a significant influence on streetwear**, blending high fashion and urban culture.

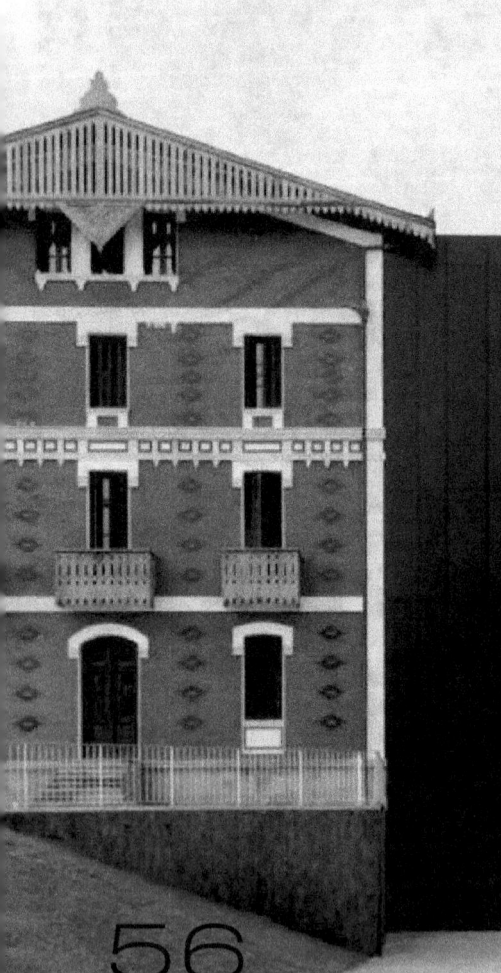

56

The Balenciaga Museum in Getaria, Spain, reopened in 2011, offering a detailed view of the founder's legacy and designs.

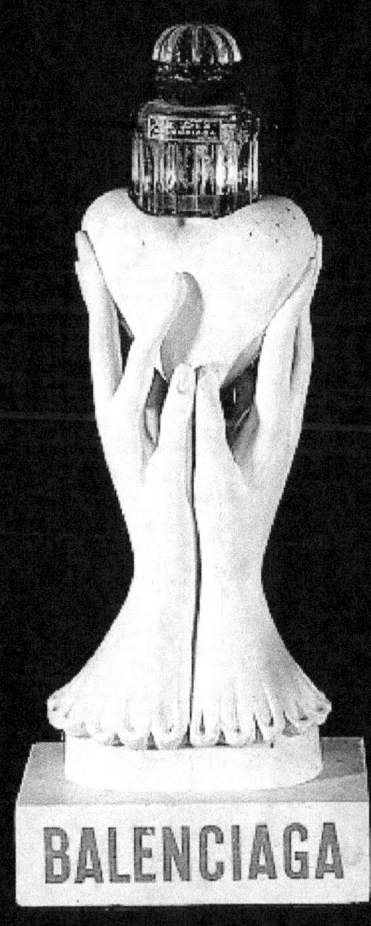

57

Cristóbal Balenciaga's designs are exhibited in museums around the world, including the Metropolitan Museum of Art in New York, testifying to their artistic and historical value.

Balenciaga has become **a symbol of status and luxury** in contemporary culture, representing not only fashion, but also a certain way of life and prestige.

BALENCIAGA

"A fashion designer must be an architect for plans, a sculptor for form, a painter for color, a musician for harmony and a philosopher for measurement."

www.ingramcontent.com/pod-product-compliance
Lightning Source LLC
Chambersburg PA
CBHW052329220526
45472CB00001B/342